The Early Development

Raphael Sanzio was born in Urbino on 6 April 1483, a year after the death of Duke Frederick II. As Urbino's political leader and major artistic patron, Frederick had transformed the small hill town near the borders of Romagna, Tuscany and the Marches into a prosperous city which gathered cultural influences from the north and center of the Italian peninsula and which occupied an advanced position in the fields of art, literature and courtly custom in the last decades of the Quattrocento.

Urbino's good fortune grew with Frederick although it outlived him by very little, for Urbino was surrounded by powerful neighbors: Venice, Florence and the Papal States. The Duke had unified the Duchy of Montefeltro, which was legally under Papal power but which had actually split into many small feudal possessions. As the organizer of mercenary armies which he placed at the disposal of various Italian states, he increased his personal treasure and contributed greatly to the wealth of his city, which in this way came to know the most prosperous moment in its history.

This prosperity permitted numerous cultural and artistic initiatives, many of which are still visible today. Artists like Paolo Uccello — whose *Miracle of the Host* (1465-1469) is one of the freshest and liveliest narratives of the Quattrocento — and Piero della Francesca — who executed several masterpieces, among them the *Flagellation* (1455) and the *Portraits of Duke Frederick and Battista Sforza*, his wife (1465) — were attracted by the generosity of the leader-patron and by the initiatives and projects he proposed. Afterwards came those who showed themselves to be closest in thought and deed to the personality of the Duke: Justus of Ghent (who, in Urbino, combined the analytical characteristics of Flemish painting with the values of light and synthesis established by Piero della Francesca), Melozzo da Forlì, Filippo Brunelleschi, Luciano and Francesco Laurana, Francesco di Giorgio Martini (sculptor, painter and builder of fortifications) and Giorgio Schiavone.

This mixture of talent and activity gave rise to the construction of the massive and fanciful Ducal Palace and to the creation of a vaste and notable artistic circle.

Urbino was capable of mediating the most varied artistic tendencies, from the Venetian to the Florentine to the Umbrian. Its culturally and artistically fertile ground formed the substratum in which the composite and receptive art of Raphael is rooted.

Raphael was born, as we said, on 6 April 1483, to Giovanni Santi and Màgia Ciarla. His father, a painter, was well known in artistic circles in Urbino, even if he is better known in the history of art for his poetic eulogy of contemporary painting in the *Chronicle* of the deeds of Frederick II, written immediately, after the Duke's death. His works contain motifs from various sources, among them Piero,

Perugino (active in the Marches, in Fano and Senigallia, minor towns in the Duchy of Montefeltro) and Melozzo da Forlì.

Two artists were working in his father's workshop during Raphael's childhood. Evangelista da Pian di Meleto (whose artistic production has yet to be reconstructed) and Timoteo Viti da Urbino, who returned to his native Urbino from Bologna in 1495. The latter undoubtedly more deeply influenced the very young Raphael. The elements which this painter lacks — a sense of proportion and of composition — are visible in Raphael's early works, the first of which is, in Longhi's opinion, the *Banner* of Città di Castello (c. 1499). This work, which is in effect two paintings placed back to back, represents the *Crucifixion* on one side and the *Madonna of Mercy* on the other. The masterfully executed Madonna reflects the art of Piero della Francesca.

Around the beginning of the 16th century Raphael met Pietro Perugino, who influenced his painting perhaps more than any other painter. Perugino, who had been praised by Raphael's father in the *Chronicle*, reached his greatest fame in the last years of the Quattrocento. In addition, documents show that Raphael collaborated with Evangelista da Pian di Meleto on the altarpiece commissioned in 1510 for the Church of Sant'Agostino in Città di Castello. This piece, whose surviving parts are now dispersed in various Euro-

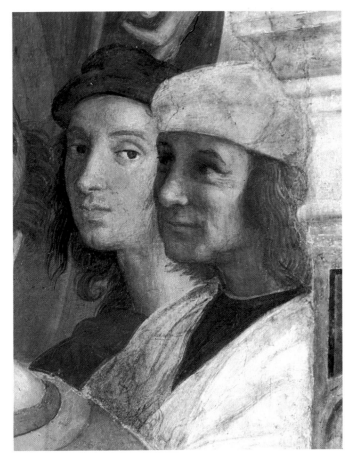

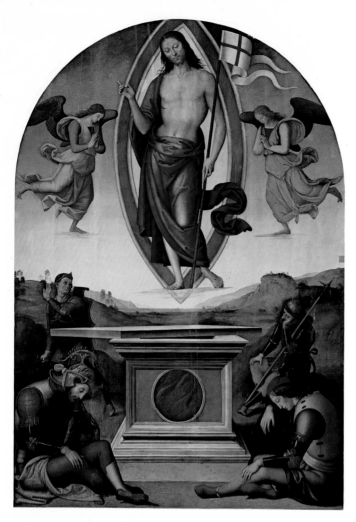

*2. School of Perugino
Resurrection
Vatican, Pinacoteca*

*3. St Sebastian
43x34 cm
Bergamo, Accademia Carrara*

chronologically by the *Resurrection* of 1501 in the Vatican Museum. This painting has also been cited as a work of collaboration by critics anxious to reconstruct the activity of the young Raphael during his association with Perugino. But today most critics agree that nothing in this panel — which is characteristic of the weak and mannered art that Perugino produced during this period — reveals Raphael's hand.

The contrary is true of the *St Sebastian* in the Carrara Academy in Bergamo. Here, graceful Peruginesque poses and the hazy transparency of color characteristic of Francesco Francia, are fused together in a way that clearly indicates Raphael's presence. His ability to compose clear and balanced forms becomes typical from this work on, as does the discreet and harmonious distillation of the formal elements of other painters in the clear, serene vision which seems characteristic of his artistic temperament.

The presence of Peruginesque motifs in Raphael's work is still quite evident in the *Crucifixion* of 1502-1503, now in the National Gallery in London. This painting originally formed the central part of an altarpiece commissioned for the Church of San Domenico in Città di Castello. It is the first work that Raphael signed. The signature, "Painted by Raphael of Urbino," documents his full artistic autonomy and indicates his background.

The composition derives from other panels on the same subject painted by Perugino; for example, the imposing Chigi Altarpiece for Sant'Agostino in Siena. But the rigorous correspondences of gesture that distinguish Raphael's figures from the sentimental and obvious poses of the master, clearly set the young pupil apart. The faces are treated with a subtler *chiaroscuro* and the volumes are, as a result, more slender than those of Perugino. Thus Raphael — even though he is unwilling and, perhaps, unable to break away from Perugino's influence — shows his true temperament in this painting. This temperament includes an extraordinary feeling for proportion and an acute visual sensibility. It is even more evident in the two predella compartments — one in the Cook Collection in Richmond and the other in the Lisbon Gallery — with *Stories from the Life of St Jerome*.

The works which conclude the young painter's Umbrian apprenticeship date to the years immediately after the London *Crucifixion*. They represent steps in a slow process which moves from the rejection of assimilated forms to a search for new figurative elements through which the artist can express his needs for clarity and formal balance.

In 1502-1503 Raphael also executed the *Coronation of the Virgin*, now in the Vatican Museum. This commission, originally intended for the Church of San Francesco al Monte in Perugia, was first awarded to Perugino, who entrusted it to his pupil. The altarpiece combines two scenes common in Quattrocento iconography: the Coronation (which occupies the upper part of the picture) and The Giving of the Girdle to St Thomas (in the lower part), an episode traditionally associated with the Assumption. The

pean and American museums, shows Peruginesque motifs, identifiable in the poses and features of the figures, though the grace of the compositions and the firmness of the figures surpass Perugino's capabilities.

As Venturi affirms, there must have been a "thorough familiarity with the master" behind "such a [profound] absorption of Peruginesque elements" in this early work by Raphael. Perhaps the only opportunity the young painter had to assist the master was provided by a fresco for the Collegio del Cambio in Perugia (1500). Here some critics, supported by tradition, claim to see the hand of the nineteen-year-old Raphael in the figure of *Fortitude*, which recalls certain aspects of Francesco Francia as transmitted by Timoteo Viti, his close follower.

Perugino's fresco for the Collegio del Cambio is followed

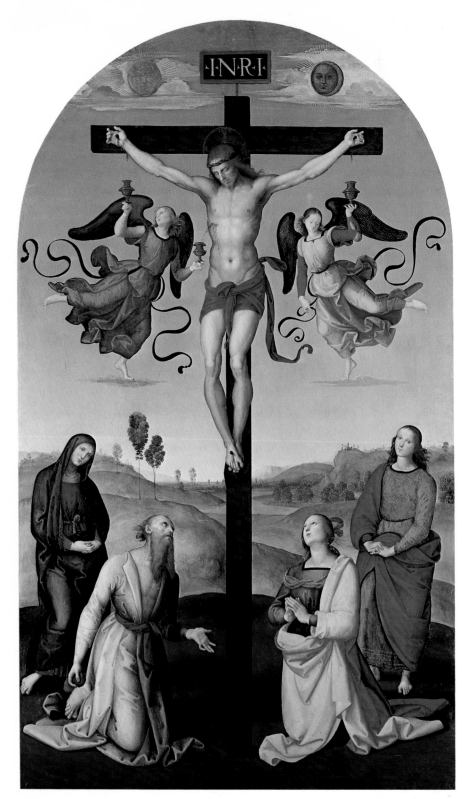

4. *Crucifixion (Città di Castello Altarpiece)*
279x166 cm
London, National Gallery

5. *Coronation of the Virgin (Oddi Altarpiece)*
267x163 cm
Vatican, Pinacoteca

two scenes remain separate from one another, and this clear division of the composition may indicate the painter's uncertainty of his compositional abilities. Nevertheless, the forms are already mature and certain innovations in perspective — such as the diagonal representation of the Madonna's tomb — constitute a departure from traditional Quattrocento compositional types. Extant drawings demonstrate the tremendous amount of thought which Raphael put into the panel's realization and some details, notably the highly individualized faces of the Apostles and the serene landscape in the background, are quite masterful. But the most meaningful passages are found in the predella scenes: the vast space which opens out beneath the colonnades of the *Annunciation*; the highly animated *Adoration of the Magi*; and the free quality of the atmosphere in the *Presentation in the Temple*, which foreshadows the extraordinary spatial intuition of some of the artist's future Vatican compositions.

Raphael was ready for new figurative experiments after these accomplishments. The search for further elements to

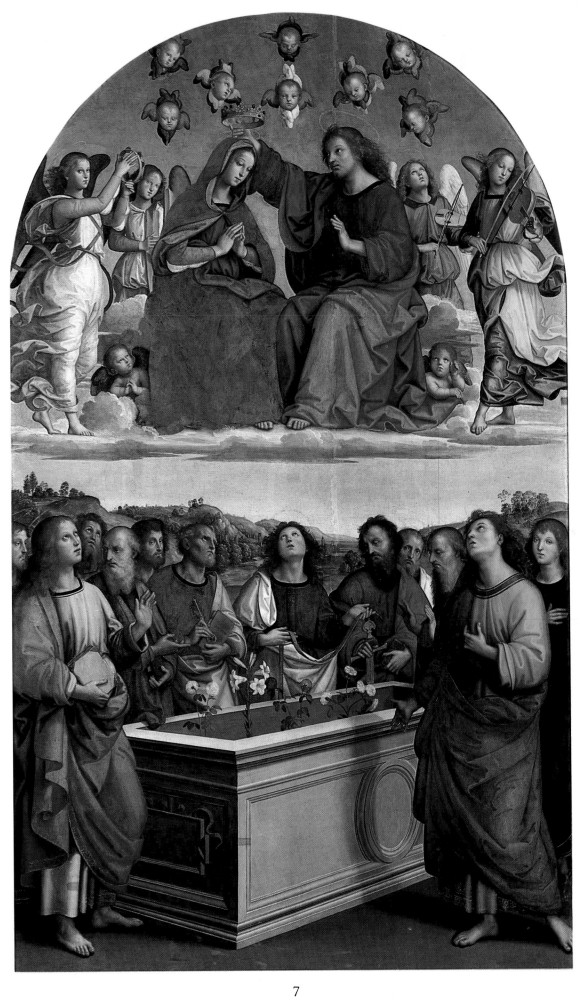

add to traditional modes of representation led him to Florence. Here a great demand for artists of all backgrounds continued to thrive, notwithstanding the terrible upheaval which the city suffered during this period.

Florence at the turn of the century was in the midst of a vast cultural and political crisis. Many of the artists who had developed the cultural values which characterized the city during the Quattrocento had either died or gone elsewhere and, as a result, these values were beginning to lose their splendor. This cultural crisis was complicated by political events, such as the invasion of Charles VIII of France and the consequent expulsion of Piero di Lorenzo de' Medici in 1494, and the dramatic experience of Savonarola which culminated in the public burning of the friar in 1498. Nevertheless, a great demand for artists of all sorts continued to exist. Many important works of art had survived the city's spiritual and political trauma and public participation in the artistic process was, as always, more lively in Florence than elsewhere.

One must not interpret Raphael's Florentine experience as a prolonged stay, for it was at most a series of brief visits which brought him into contact with some of the artists living there. The numerous works which Umbrian commissions continued to draw from him suggest that Raphael returned to Perugia frequently.

One such work is the celebrated *Marriage of the Virgin* now in the Brera Museum in Milan. This panel was commissioned by the Albizzini family of Città di Castello and was destined for the Church of San Francesco. Critics believe the painting to be inspired by two compositions by Perugino: the celebrated *Christ Delivering the Keys to St Peter* from the fresco cycle in the Sistine Chapel and a panel containing the *Marriage of the Virgin* now in the Museum of Caën. The structure of Raphael's painting, which includes figures in the foreground and a centralized building in the background, can certainly be compared to the two Perugino paintings. But Raphael's painting features a well developed circular composition, while that of Perugino is developed horizontally, in a way still characteristic of the Quattrocento. The structure of the figure group and of the large polygonal building clearly distinguish Raphael's painting from that of

his master. The space is more open in Raphael's composition, indicating a command of perspective which is superior to Perugino's. Some critics believe that Raphael's perspective construction reflects the architectonic research of Leonardo da Vinci and Donato Bramante. The work, signed and dated 1504, provides a good example of Raphael's style during this period.

Another Umbrian commission which seems to be bound up with Raphael's first visit to Florence and which presupposes, as we have noted, that the artist returned to Perugia, is the *Colonna Altarpiece* in the Metropolitan Museum, New York. The work is also called the *Madonna Enthroned with Saints Peter, Catherine of Alexandria, John, Cecilia (or Margaret) and Paul*. It was executed for the Sisters of St. Anthony of Perugia and is generally dated 1503-1505. Figurative elements which echo the style of Perugino and traces of Florentine painting from the first years of the Cinquecento, appear here in equal measure. The compositional structure of the angels in the lunette still reflects the Umbrian tradition, but a soft *chiaroscuro* which may derive from Leonardo is visible in the face of the central figure of God the Father. The vigorously conceived saints of the altarpiece itself recall the technique of Fra Bartolomeo della Porta, the Florentine painter and Dominican friar whose influence on Raphael's style is explained in greater detail below. This is particularly true for the figure of St Paul, constructed in the decisively monumental way which typifies the friar's style.

The three predella panels, containing representations of *The Way to Calvary*, the *Agony in the Garden* and the *Pietà*, surpass the figurative themes of the preceding century. In all three panels the atmospheric effects are freer than in previous works and the figures are more autonomous in the space they occupy. The sculptural quality of the *Way to Calvary* represents a definite departure from Quattrocento decorative tendencies. Raphael's encounter with contemporary Florentine art has begun to push the teachings of Perugino into the background and to prepare the way for the complete autonomy of expression which reveals itself in the following year.

Raphael in Florence

In 1505 Raphael was in Florence. The most notable artists active at the time were Leonardo Da Vinci, Michelangelo Buonarroti and the above-mentioned Dominican friar, Bartolomeo della Porta. Each of these artists had developed a different style of painting, but all were involved in a search for figurative elements which surpassed the Quattrocento models and for an expressive language in which color was more unified and space was freer.

Raphael became involved in this search, which goes be-

yond the lively curiosity of the first Florentine Renaissance and presupposes a new breadth of forms and a greater freedom of thought. Leonardesque "shading", which fused the representation of man and nature together in a single vision, replaced the Quattrocento notion of "functional line" (to use Berenson's term), the clearly defined contour which both delineated the figure and represented its movement. At the same time, a new, more monumental compositional type arose (though essentially new, it had already been

6-8. Predella of the Oddi Altarpiece representing the Annunciation, the Adoration of the Magi and the Presentation in the Temple 27x50 cm each panel Vatican, Pinacoteca

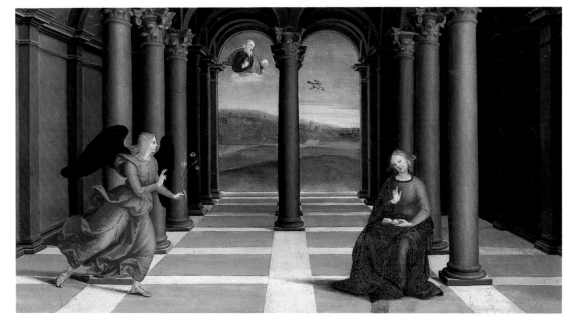

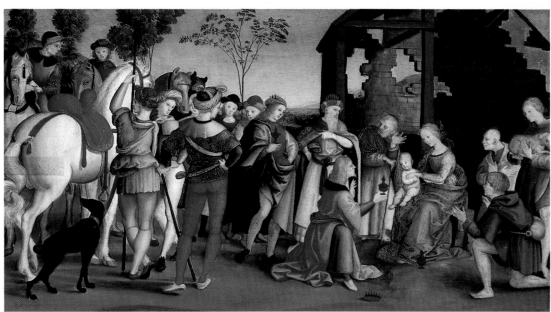

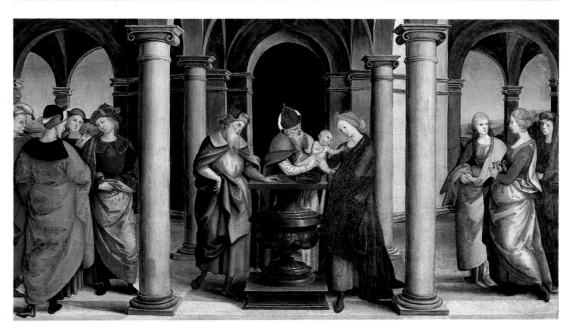

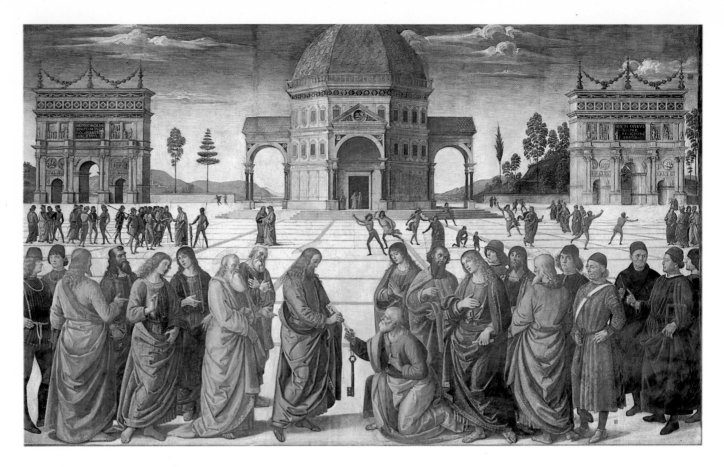

foreshadowed in the works of some Quattrocento masters, for example, in the *San Barnaba Altarpiece* by Botticelli, 1486). It first appears in the art of Fra Bartolomeo who seems to be the artist to whom Raphael turned most of his attention at this time.

Raphael abandoned every trace of Peruginesque influence in Florence and returned to Umbria in the same year with new pictorial motifs which he was to express in two notable works, the *Colonna Altarpiece* (which we have already examined) and, a bit later, the *Ansidei Madonna*, also known as the *Enthroned Madonna with Saints John the Baptist and Nicholas of Bari*. This *Sacra Conversazione*, attributed to the years 1505-1506, shows the Virgin attentively reading a prayer book, with the Child in her lap. The two saints stand at her sides. The Baptist points to the Child (a traditional iconographic device) and St Nicholas is absorbed in a volume which he holds in his hand. The luminous landscape background and the high baldachin remotely recall the art of Piero della Francesca, but the figure types, still vaguely Peruginesque in their contours, are psychologically more complex and structurally more volumetric. The compositional scheme is reduced to a large arch whose central axis is represented by the baldachin. The result is a sense of monumentality and harmonic proportion which were to become constant in Raphael's art.

The figurative powers which Raphael developed in Florence led to "a more synthetic conception of form, a refinement of intellectual expression" (Venturi), which are visible in the *Knight's Dream* in the National Gallery, London, and the *Three Graces* of Chantilly. Critics believe that the two

9. Perugino
Christ Delivering the Keys to St Peter
Vatican, Sistine Chapel

10. *The Marriage of the Virgin*
170x121 cm
Milan, Brera Museum

panels may have formed a single diptych presented to Scipione di Tommaso Borghese at his birth, in 1493. The theme of the paintings may by drawn from the poem, *Punica*, by Silius Italicus, which was well known in antiquity and which humanistic culture restored to fame. In the first panel, Scipio, the sleeping knight, must choose between Venus (pleasure) and Minerva (virtue); in the second, the Graces reward his choice of virtue with the Golden Apples of the Hesperides. The classical origin of this theme brings us back without doubt to the Florentine environment. The composition, which is dominated by a sense of great harmony, is a figurative consequence of the literary theme.

These panels, which were originally attributed to the first period of Raphael's activity, are now thought to have been painted around 1504-1505. By comparing them to one another, we can begin to identify Florentine influences. An analytical rendering of detail distinguishes the first panel, while an abstract quality characterizes the second. The landscape background is deep and spatious and is reduced to broad fields of color. The figures of the three Graces

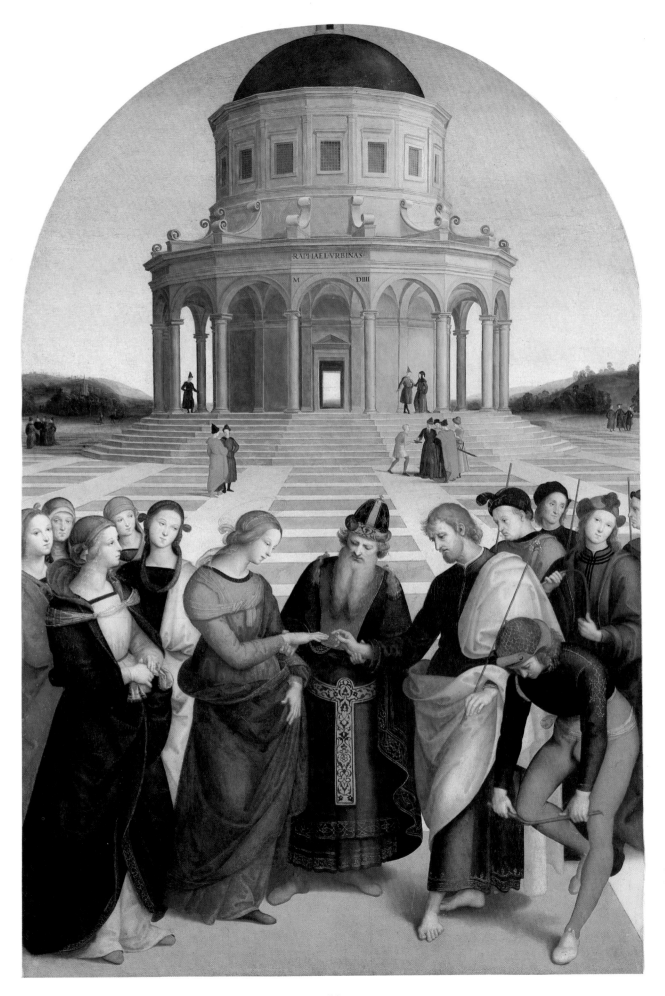

11

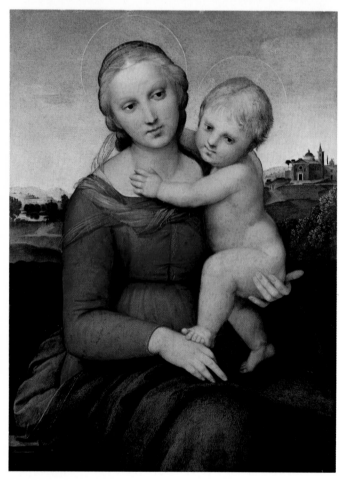

which dominate the foreground are solidly constructed, but they are also modelled by a delicate *chiaroscuro*.

The *Madonna del Granduca* (1504) in the Pitti Gallery in Florence shows the pre-eminent influence of Leonardo. Its simple composition is a prototype for the future Madonnas of Raphael's last Florentine period. The figures of the Virgin and Child emerge from a dark background (an element evidently derived from Leonardo), bound together by a sweet sentiment which derives largely from the gesture of the Child who, while looking toward the spectator, presses against his Mother. The painting belonged to the 17th century Florentine painter, Carlo Dolci, and then to Grand Duke Ferdinand III of Lorraine from whom its name derives.

The *Small Cowper Madonna*, today in the National Gallery in Washington, is a more analytical variant of the homogeneous and resolute group of the *Madonna del Granduca*. Here the painter expresses the influence of Leonardo in a broad, soft landscape. This landscape contains a small church with a cylindrical dome, which may be an allusion to Bramante's architecture. According to Venturi, it recalls the Church of San Bernardino in Urbino. The painting is generally dated 1503-1505.

The *St Michael* and *St George and the Dragon* in the Louvre, and the *St George* of the National Gallery in Washington are bound together both by their subject — an armed youth fighting a dragon — and by stylistic elements. All three are assigned to the Florentine period and echo those stimuli which Raphael received from the great masters who worked in Florence or whose paintings were visible there. The influence of Leonardo — whose fighting warriors from the *Battle of Anghiari* (1505) in the Palazzo della Signoria provided an extraordinary example of martial art (the painting deteriorated very rapidly because of shortcomings in Leonardo's experimental technique and so is no longer visible) — predominates in these works. But references to Flemish painting — particularly that of Hieronymus Bosch (the glaring light and humanoid monsters which populate the *St Michael* are characteristic of Bosch) — suggest the environment of Urbino, where Northern influences were still quite vivid. Raphael's imagination, which is particularly developed in the details of the *St Michael*, is more balanced in the figure of the Archangel, the focus of the entire composition. This sense of balance and composure is developed further in the other two panels, where the landscape, still of Umbrian derivation, accentuates the serenity of the figures, notwithstanding the dramatic character of the subject. Certain qualities of light, like the reflections on the armor in the Washington *St George*, foreshadow the compositions of the Vatican "Stanze" (see the *Liberation of St Peter*). These small panels are indicative of a moment in which the painter gathers the stylistic fruits of what he has assimilated so far and, at the same time, poses pictorial problems which will be developed in the future.

The *Portrait of a Young Man with an Apple* (1505) in the Uffizi has been associated with these paintings. It is difficult

11. *Madonna and Child (Connestabile Madonna)*
dia. 17.9 cm
Leningrad, Hermitage

12. *Madonna and Child (The Small Cowper Madonna)*
58x43 cm
Washington, National Gallery of Art

12

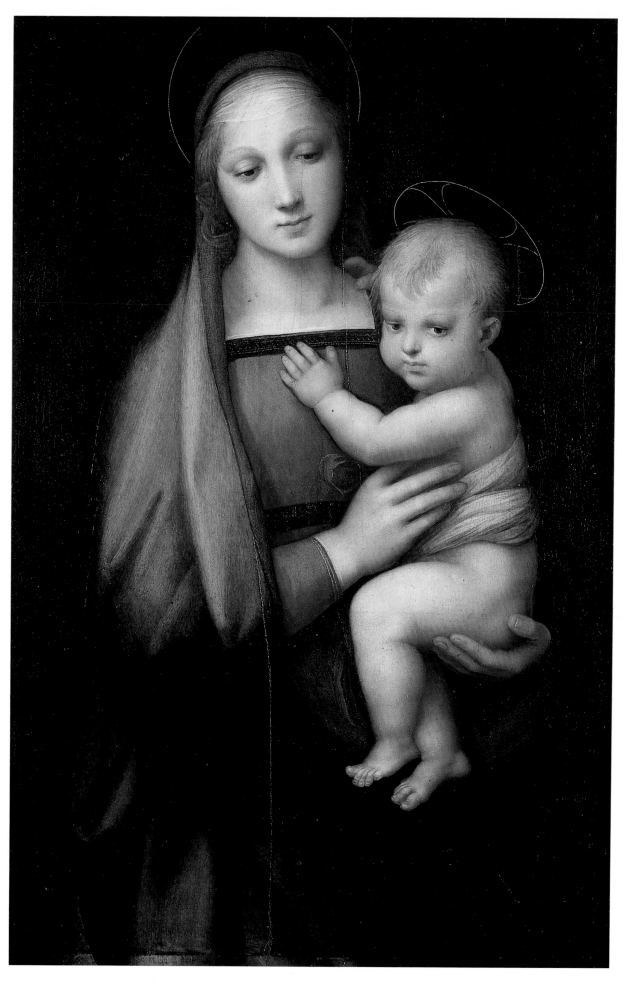

to perceive the hand of the artist in the face which, although beautifully drawn, lacks the physiognomic characteristics which typify Raphael's subjects. But the overall attention to the analytical effects of Flemish art leads us to attribute the work to Raphael, since his attention was turned to the production of this school precisely in these years. Furthermore, the compositional harmony which is a principal element of Raphael's art is visible in the compact forms of the solidly conceived portrait. The subject has been associated with Francesco Maria Della Rovere, and possibly correctly: the portrait reached Florence with the Della Rovere patrimony in 1631 on the marriage of Vittoria Della Rovere to the future Grand Duke Ferdinand II.

Another important aspect of Raphael's Florentine stay is the compositional evolution which his painting underwent. Perugino's compositions — like those of all Quattrocento masters — were based on linear rhythms. In Florence Raphael transformed his compositional type in a constructive-monumental sense. This transformation is recognizable mainly in the human figures, who are still harmonically enclosed in geometric schemes and accompanied by a clear daylight in the background.

An example of his ability to resolve natural elements in a synthetic vision which transcends particular situations is the portrait of a woman called *La Donna Gravida* in the Pitti Gallery, Florence. The subject is a pregnant woman, conscious of her approaching motherhood, who looks intensely toward the spectator, with her hand on her abdomen. The portrait is finely balanced. Solid forms are reduced to pure spherical volumes, overlaid with carefully chosen colors. The sense of color which this painting shows will be used again by Raphael in his portrait of Cardinal Fedra Inghirami.

The same conceptual content underlies the *Woman with a Unicorn* in the Borghese Gallery, Rome. This painting, which shows a young woman holding a small unicorn, was discovered during a restoration in 1930. Until then it had been covered by the image of a female saint with the iconographic attributes of St Catherine of Alexandria. Present day critics attribute the work to Raphael, referring it to 1505 and to the Florentine environment. It can, in fact, be inserted among the portraits of that period, for it represents an apex in the artist's stylistic development. The fullness of the well constructed figure is set apart from a vast landscape background, inspired by Leonardo but executed with the clarity typical of Raphael.

Leonardo's influence is particularly strong in *the Blessing Christ* (c. 1506) in the Tosio-Martinengo Museum in Brescia. Here Christ is shown emerging from the tomb. He is no longer an object of compassion, as in 14th and 15th century panels. Rather, he is depicted as the Resurrected Christ; he still bears the symbols of the Passion, the crown of thorns and the marks of the nails which bound his hands and feet to the Cross. Every element of the artist's experience with Perugino has by now been abandoned. The figure displays a smoothness of surface and a soft *chiaroscuro* modelling which clearly surpass the abilities of Raphael's master.

The controversial *Self-Portrait* in the Uffizi is very similar to the *Blessing Christ*, but its poor state of conservation has prevented critics from attributing it objectively and definitively to Raphael. Nevertheless, many art historians consider it a work from the Florentine period. The soft light which pervades the portrait certainly recalls Leonardo, but the restless and problematic elements which Leonardo's complex figurative research present are absent. The intense representation of the youth shows no sign of internal tension. On the contrary, it communicates a serene observation of reality through a pictorial rendering rich in synthetic capacity.

The masterpieces of this period are undoubtedly the *Portraits of Agnolo and Maddalena Doni* in Palazzo Pitti. The merchant Agnolo Doni married Maddalena Strozzi in 1503, but Raphael's portraits (which remained in the family until 1826, when they were acquired by Grand Duke Leopold II of Lorraine) were probably executed in 1506, the period in which the painter studied the art of Leonardo most closely. The composition of the portraits resembles that of the *Mona Lisa*: the figures are presented in the same way in respect to the picture plane, and their hands, like those of the *Mona Lisa*, are placed on top of one another. But the low horizon of the landscape background, a "distant heir of Piero della Francesca" (Longhi), permits a careful assessment of the human figure by providing a uniform light which defines surfaces and volumes. This relationship between landscape and figure presents a clear contrast to the striking settings of Leonardo, which communicate the threatening presence of nature. But the most notable characteristic that distinguishes these portraits from those of Leonardo is the overall sense of serenity which even the close attention to the materials of clothes and jewels (which draw one's attention to the couples' wealth) is unable to attenuate. Every element — even those of secondary importance — works together to create a precise balance. These works, linked not only by the kinship of the subjects, but also by their evident stylistic homogeneity, mark the beginning of Raphael's artistic maturity.

Raphael's stylistic evolution also regards composition, as we have noted. He develops the pyramidal scheme of Leonardo da Vinci and combines it with the monumental compositions of Fra Bartolomeo. His main interest is to maintain formal balance. The controlled use of light is one of the chief tools he uses to achieve this goal. At the same time, he welcomes new tools, among them the figurative motifs of Michelangelo.

Michelangelo's influence on Raphael is evident in the *Madonna of the Meadow*, one of the compositions featuring the Madonna, the infant Christ and young St John which mark the central point of Raphael's activity in Florence. The pyramidal structure of the figure group again recalls Leonardo (whose cartoon for the *St Anne* was shown in 1506 in the Church of Santissima Annunziata). But Raphael exerts his own balancing capacity on the Leonardesque volumetric

13. Madonna and Child (Madonna del Granduca)
84x55 cm
Florence, Galleria Palatina (Pitti Palace)

14. The Three Graces
17x17 cm
Chantilly, Musée Condé

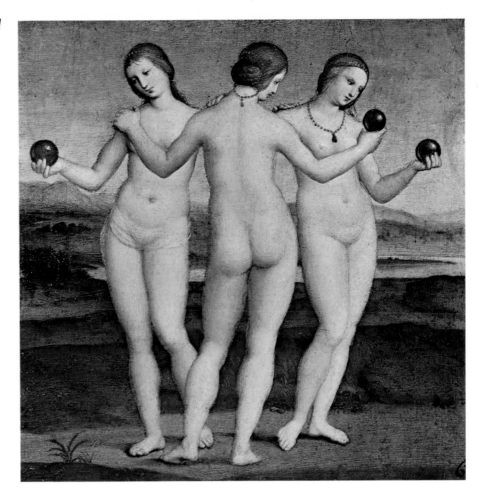

15. The Knight's Dream
17x17 cm
London, National Gallery

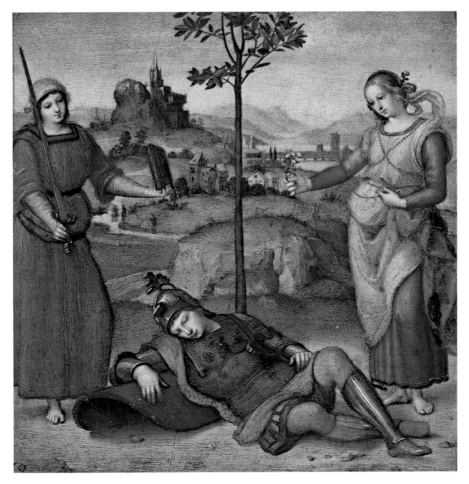

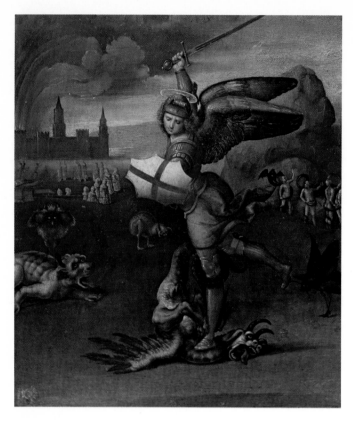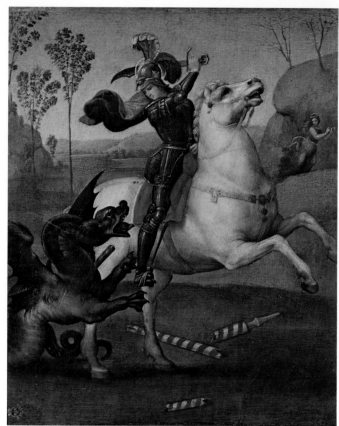

16. St Michael and the Dragon
31x27 cm
Paris, Louvre

17. St George and the Dragon
31x27 cm
Paris, Louvre

conception, infusing it with the idyllic serenity which characterizes his paintings from this period. The work as a whole is structurally harmonic, from the figure group (dominated by the affectionate figure of the Virgin Mary who supports the Child and glances tenderly at the young St John) to the sweeping landscape (made luminous by the mirror-like lake which stretches from one side of the panel to the other). The twisting figures of the two children clearly reflect Michelangelo's figurative research. They are also visible in a nearly contemporary panel, called *La Belle Jardinière*. The *Madonna of the Meadow*, now in the Kunsthistorisches Museum in Vienna, passed from the Taddei family (for whom it was executed) into the Austrian collections in the 18th century. It is signed and dated 1506.

The *Madonna of the Goldfinch*, executed in 1507 for Lorenzo Nasi and now in the Uffizi, is another of Raphael's Florentine panels. It was severely damaged following the partial collapse of the Nasi house in 1547, as mentioned by Vasari. It was subsequently restored by Michele di Ridolfo del Ghirlandaio, the son of the artist who was deeply influenced by Raphael. The composition follows that of the *Madonna of the Meadow*, with the essential difference that the children in the *Madonna of the Goldfinch* are more firmly united with the central figure of the Virgin. The color is more lively than that of the *Madonna of the Meadow* and foreshadows the coloristic character of Raphael's Roman paintings. The landscape, and particularly the architectural forms it contains, reflects the influence of Flemish art, even though it is still structured in the Umbrian manner. This influence was as alive in Florence as it was in Urbino in the second half of the Quattrocento. It is perhaps most visible in

the sloping roofs and tall spires, unusual elements in a Mediterranean landscape. The influence of Michelangelo is again evident in the well structured figure of the infant Christ. It was to become even more evident in the works which followed.

The so-called *Belle Jardinière*, now in the Louvre, follows the *Madonna of the Goldfinch* chronologically. Its composition is a mirror image of that of the *Madonna of the Meadow*. The painting was commissioned by Fabrizio Sergardi, a Sienese nobleman, and was left uncompleted by the artist. Nevertheless, it is signed and dated 1507. According to tradition it was finished by Ridolfo del Ghirlandaio, although the recent restoration would seem to contradict this attribution. It was subsequently acquired by Francis I of France. The painting is known primarily for the harmonic and proportional balancing of the poses of the figures and for the high formal quality present in every element, particularly in the face of the Virgin, which served as a model of beauty for generations of artists.

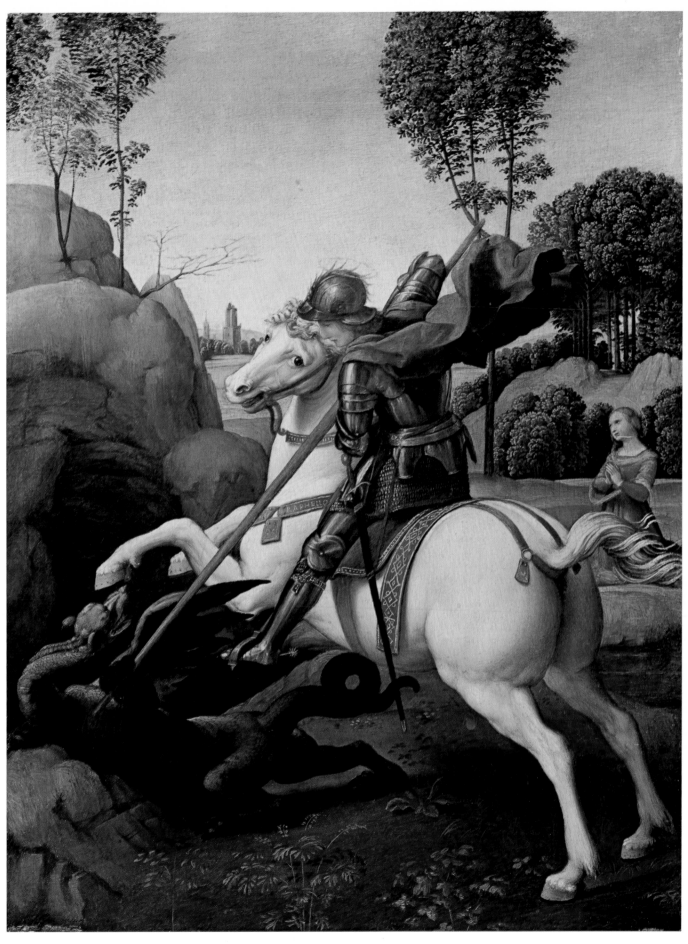

18. St George and the Dragon; 28x22 cm; Washington, National Gallery of Art

17

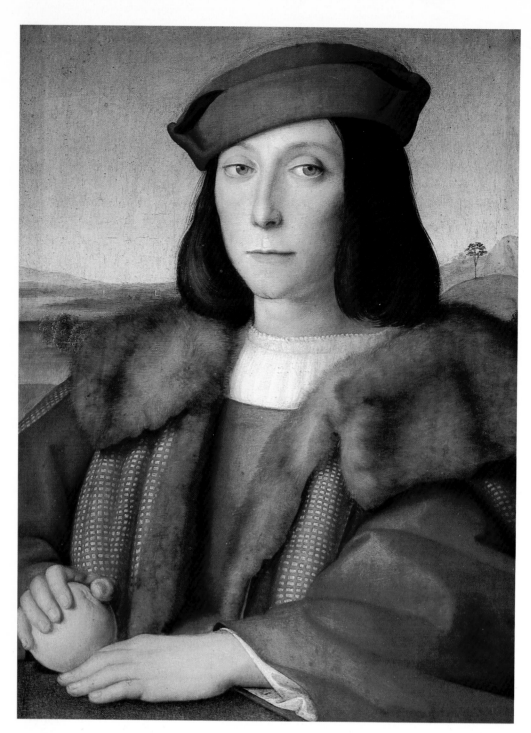

19. Portrait of a Young Man with an Apple
47x35 cm
Florence, Uffizi

Between Florence and Rome

Among the figurative components which Raphael drew from his Florentine experience (which, as we have seen, was interrupted by frequent trips to Umbria), those which derive from Michelangelo seem most prevalent in his last Florentine works. The work in which Michelangelo's importance to Raphael becomes most evident is the *Entombment*, now in the Borghese Gallery in Rome. The panel was painted in 1507 in Perugia for Atalanta Baglioni as a votive offering in memory of her son, Grifonetto, killed in a piazza in Perugia in the course of a family feud. The artist detaches himself both formally and iconographically from traditional representations of the scene. He does not depict the deposition itself, but the carrying of the dead Christ. The protagonists of the scene do not demonstrate their sorrow violently, but are reduced, through the Raphaelesque mode of feeling, to a sort of painful resignation. Critics have

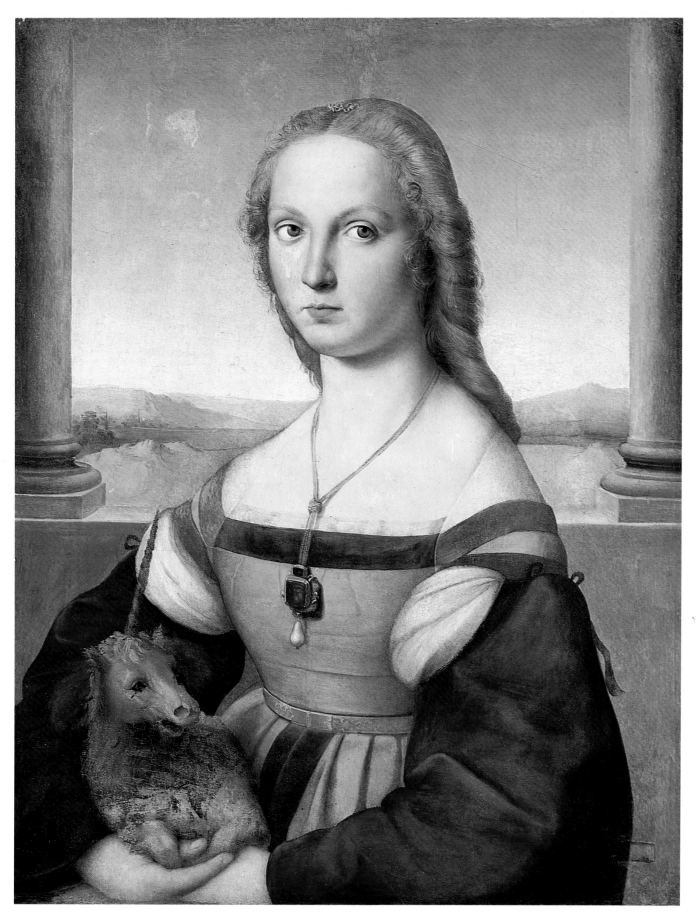

20. The Woman with the Unicorn
65x51 cm
Rome, Galleria Borghese

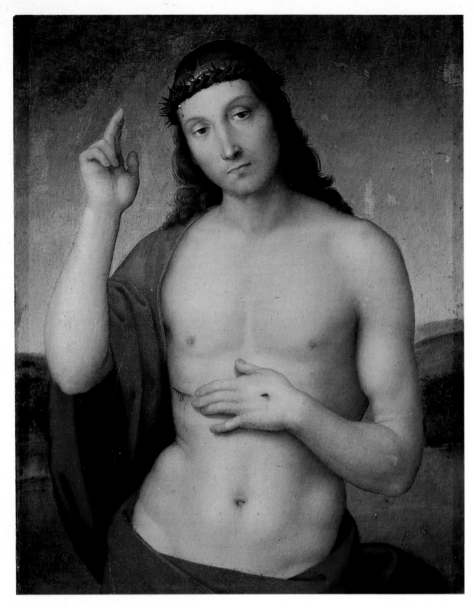

21. The Blessing Christ
30x25 cm
Brescia, Pinacoteca Tosio Martinengo

22. Madonna Enthroned with Saints
John the Baptist and Nicholas of
Bari (Ansidei Altarpiece)
274x152 cm
London, National Gallery

pointed out a resemblance between Raphael's *Entombment* and classical bas-reliefs illustrating the carrying of Meleager, a hero of Greek mythology. The vision of space is less geometric than the Florentine vision, and it appears freer and closer to nature. The influence of Michelangelo is strong, however, and can be perceived without doubt in the limp arm of Christ as well as in the female figure at the extreme right. The latter mirrors the figure of the Virgin in the *Tondo Doni*, which Michelangelo executed between 1504 and 1506. The formal vigor and sense of open space which characterize Michelangelo's painting certainly must have had a profound effect on Raphael.

The three compositions of the predella (today in the Vatican Museum) are executed in a delicate monochrome. They represent Faith, Hope and Charity accompanied by small angels who bear objects symbolizing the virtues. The human figure completely dominates every composition and the sense of harmony is pervasive. Even in the secondary elements of his creations, Raphael does not spare his capacity to use line and pose to create an overall image of complete formal beauty.

Both the main panel and the predella were carried from Perugia to Rome by Pope Paul V. They were replaced by copies executed in 1608. The painting was subsequently included among the works taken by the French troops and was exhibited in Paris in the Napoleonic Museum from 1797 to 1815 when, following the restitutions ordered by the Congress of Vienna, it was returned to Rome.

The *Canigiani Holy Family* in Munich is attributed to the same period as the *Entombment* (1504-1506). The painting's name derives from the Florentine family who owned it before it passed into the Medici collection and then into Germany with the marriage of Anna Maria Lodovica de' Medici to the Palatine Elector. In this work Raphael synthesizes elements drawn from Leonardo and Michelangelo and compounds them with a decisively Northern landscape and delicate coloristic passages dominated by iridescent tones. The pyramid in which the figures are ideally enclosed is still drawn from models provided by Leonardo, but the relationships between the figures, developed through the glances they exchange and through the serene feelings they communicate, carry the composition onto a

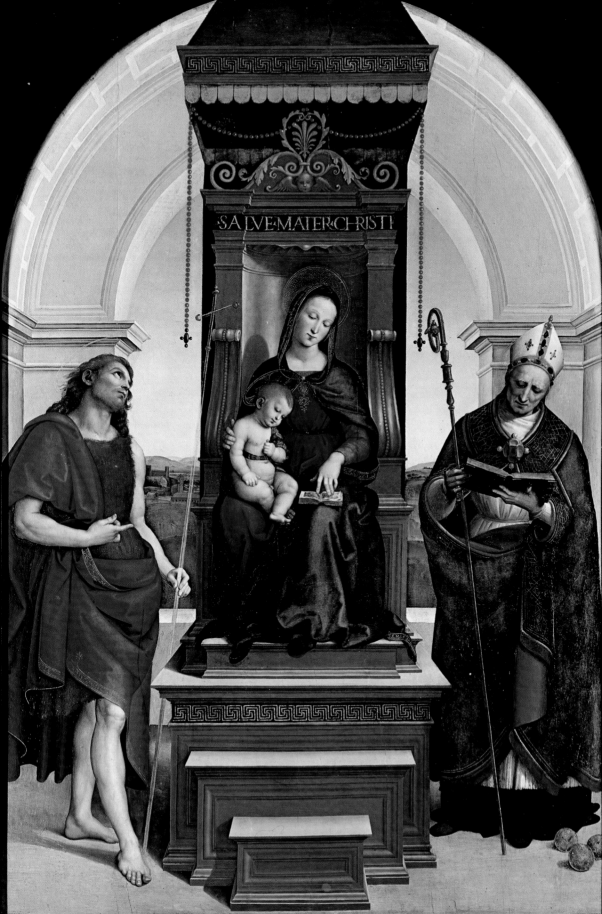

SALVE·MATER·CHRISTI

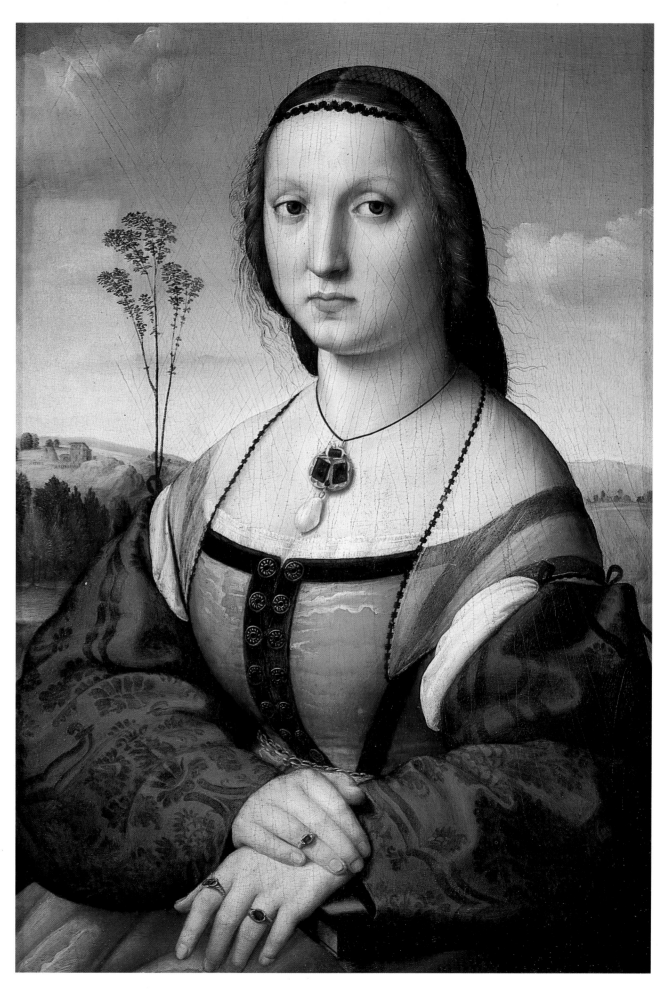

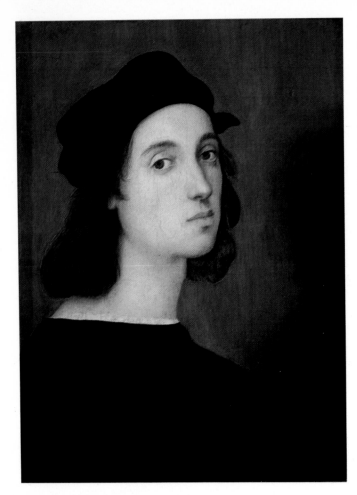

23, 24. *Portraits of Agnolo and Maddalena Doni*
65x45.7 each
Florence, Galleria Palatina (Pitti Palace)

25. *Self-Portrait*
47.5x33 cm
Florence, Uffizi

— used here in a fairly limited range — which unify the composition as a whole.

The stylistic versatility which Raphael demonstrates in contemporary or nearly contemporary works executed for a homogeneous social environment is indicative of his extraordinary technical capacity. This versatility is expressed in a variety of compositional types, which can range from simple forms to more monumental and complex ones; and in conceptual expressions, which are sometimes calm and quiet and sometimes emphatic.

This range of figurative expressions appears in another work from the Florentine period, the *Madonna del Baldacchino*, in Palazzo Pitti. This painting was begun in 1507 for the Dei family and was intended for their chapel in the Church of Santo Spirito. The panel's monumental structure derives partially from the Venetian tradition and partially from Fra Bartolomeo. The Venetian influence is visible above all in the setting: the apse of a church which recalls the larger compositions of Giovanni Bellini. The influence of Fra Bartolomeo consists mainly in the monumentality and poses of the figures. The semi-circular arrangement of the saints around the Virgin and the unusually excited flying angels who hold open the curtain of the baldachin give the painting a sense of free atmospheric circulation. The figures, all posed differently, prepare a complex of expressions which will find its natural outlet in the large descriptive compositions of the Vatican. The most recent restoration has shown that the altarpiece is entirely Raphael's work and that it was left incomplete.

Fra Bartolomeo's influence is particularly clear in the *Large Cowper Madonna* in the National Gallery in Washington. This panel, signed and dated 1508, was executed near the end of Raphael's stay in Florence. The composition is extremely simple and essential; the gesture of the Child, who stretches his hand toward the Virgin while turning his attention toward the spectator, and the gesture with which the Virgin holds the hand to her breast, provide the only signs of life. The sentiment of anxious motherhood which, enriched by greater awareness, will be fully expressed in the *Tempi Madonna*, now in the Alte Pinakothek of Munich, appears here for the first time. The Virgin, who tenderly presses the Infant to her cheek, is the subject of the painting. But the two figures are conceived as a single group, and this fact dominates the scene's visual impact. The only natural elements are a small strip of landscape and the light blue sky in the background. The Madonna's swollen mantle is meant to indicate movement. The extreme synthesis of the color fields indicates Raphael's idealization of the subject. But the painter's need for formal beauty and the emotional reality of the subject matter are reconciled above all through the tender relationship between Mother and Child. This panel, which critics place in the year 1508, is included among the works executed after Raphael's contact with Florentine art.

The *St Catherine of Alexandria* in the National Gallery, London, is also assigned to this period. The martyr is shown

calmly descriptive plane. The tone of the painting is thus quite different from the tense and restless art of Leonardo. His unsurpassed descriptive capacity permits Raphael to create an image full of human participation and limpid serenity.

The female portrait known as *The Mute Woman* represents a return to the influence of Leonardo. It certainly comes from the Florentine environment, for it was given in trust to the National Gallery of the Marches by the Uffizi, where it had been stored for several hundred years. It was attributed to Raphael only recently. Leonardo inspires mainly the pose of the figure (whose characteristically crossed hands constitute a very clear reference to the *Mona Lisa*). The neatness of the large areas of color which emerge in lighter tones from the near-black background, and the analytical treatment of the details of the woman's clothing are characteristic of Raphael. The dispersive effect of this attention to detail is fully compensated by the tones of color

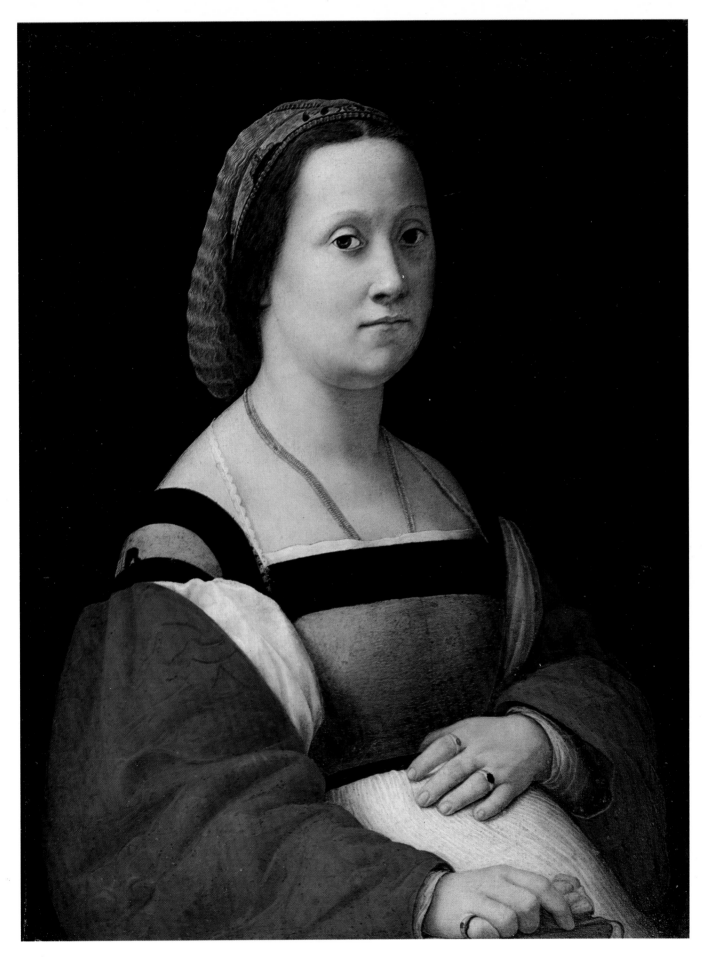

26. Portrait of a Woman (La Donna Gravida); 66.8x52.7 cm; Florence, Galleria Palatina (Pitti Palace)

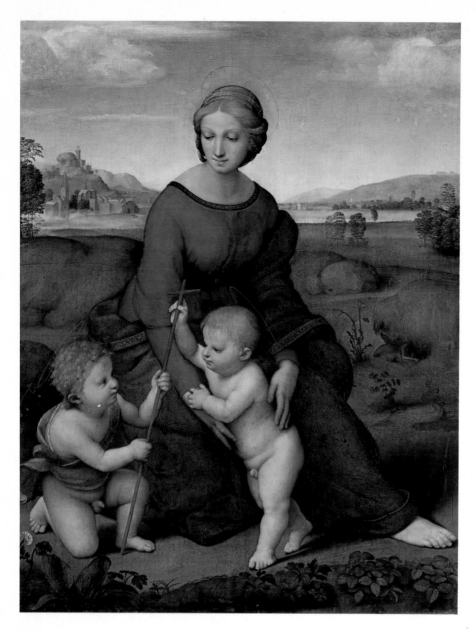

almost full figure, turned toward the sky in an act of ecstasy which foreshadows the "devotional intonation of the large Roman altarpieces" (De Vecchi). The landscape is painted with particular care. Its light shading indicates a residual influence of Leonardo, although the jagged mountains which often characterize Leonardo's landscapes are absent. The delicate modelling of the saint, the slight torsion of her body as she leans on the wheel of her martyrdom (whose spikes have been reduced to rounded knobs in order to tone down the element of cruelty) fully express the balanced character of Raphael's art. The panel clearly shows the intense formal research which underlies Raphael's figurative creations. He is always careful not to excite emotions which he considers too intense and to mitigate tones and thematic elements in search of a perfect balance between design, color, pose and expression, and between the figurative and ornamental elements.

After having passed most of 1509 in Florence, Raphael prepared to leave for Rome. That he was present in Perugia for a brief period is certain. There he executed a fresco in the Convent of San Severo which may be regarded as a predecessor of the compositions in the first frescoes of the Vatican Stanze. The painting, representing the *Holy Trinity and Saints*, consists of two parts and still shows the influence of Fra Bartolomeo, although the Umbrian environment causes Raphael to resume some elements of his experience with Perugino which he had seemed to have forgotten.

These works conclude Raphael's Florentine experience. They clearly demonstrate the stylistic knowledge and figurative means that he acquired through observing and frequenting the Tuscan masters.

Julius II Della Rovere was Pope when Raphael arrived in Rome. The group of humanists, literary figures and artists which had previously formed at the court of Urbino was reconstructed around his throne. There were close contacts between the Papal environment and that of Urbino, for the Della Rovere family dominated both Urbino and Rome. The Urbinate architect, Donato Bramante, who came to Rome from Lombardy, and whose *Tempietto* at San Pietro in Montorio was built along a central plan similar to that which

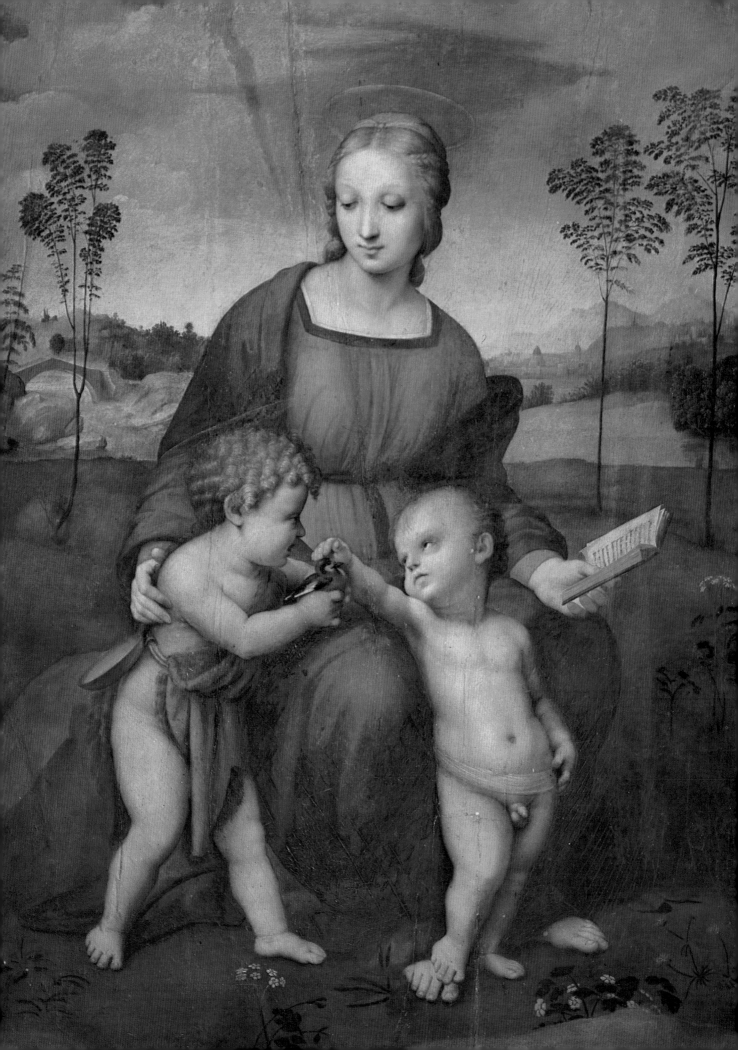

Raphael had painted in the *Marriage of the Virgin*, was particularly active. Furthermore, classical antiquity was the object of new studies and interests during the pontificate of Julius II. The discovery of an antique sculpture group, the *Laocoon*, in 1506, caused a great deal of excitement among artists and literary figures. The relocation of this and other statues from the Greek and Roman periods in the Belvedere Garden in the Vatican changed the stylistic tendencies of art in Rome. Even Raphael, who had just arrived in Rome, assimilated certain classical motifs which he believed responsive to his figurative research.

Julius II (pope from 1503 to 1513) was a complicated and dynamic personality. After having broken up the rival Borgia faction, he headed the so-called Holy League, whose goal was to drive the French out of the territories which bordered on the Papal States. This was accomplished with the aid of several Italian principalities. Julius' military undertakings were associated with an extraordinary wealth of initiatives in the re-organization of the state: he directed the re-ordering of the Papal finances (which Borgia expenditures had reduced to a deplorable state) and restored confidence in the money by minting new silver *giuli* whose nominal and real values were guaranteed to correspond. Much energy was also dedicated to city planning. New neighborhoods and streets were created (among them, the famous Via Giulia) and an ambitious project for the renewal of St. Peter's was begun. This creative fervor in the artistic field attracted the most famous artists of the time, from Antonio da Sangallo to Jacopo Sansovino, from Bramante to Pintoricchio, from Lotto to Michelangelo and from Signorelli to Raphael himself. Their presence contributed to the remaking of Rome. The political, social and demographic decadence which had afflicted the city in the Middle Ages were gradually and laboriously eliminated, and Rome became the most important cultural center in Italy.

Raphael in Rome: The Early Years

Raphael's first major undertaking in Rome was the decoration of the Stanza della Segnatura. He started work in June 1509, one year after Michelangelo had begun the vaults of the Sistine Chapel, another great pictorial cycle commissioned by Pope Julius. Both these works have a clear religious content, but their aims are different. The Sistine Chapel was intended for liturgical celebrations. Its ceiling is populated by figures who are independent of the environment and of nature and who are capable of recreating the complex and tormented expression of man's most deeply felt faith. The Stanza della Segnatura was a courtroom: its purpose was the administration of temporal power. Its decoration — harmonious settings populated by sacred and profane characters — reflected a Church by this time invested with worldly powers and occupied with their administration.

Julius II had commissioned the decoration of this room to the most well known painters active in Rome: the Sienese, Baldassare Peruzzi; the Vercellese (but naturalized Sienese), Antonio Bazzi, called "Sodoma"; the Lombard, Bramantino; and the Venetian, Lorenzo Lotto. But Raphael's program excited the Pope so much that — according to Vasari — the works already begun by the other artists were destroyed and the entire cycle was placed in Raphael's hands.

The illustrative program of the paintings of the Stanza della Segnatura, which combined antique thought with Christian humanistic re-interpretations, was certainly not conceived by Raphael. His abilities as an illustrator, however, immediately allowed him to give visual form to the complex doctrine which the subject matter implied. The accompanying diagram explains the content of the cycle:

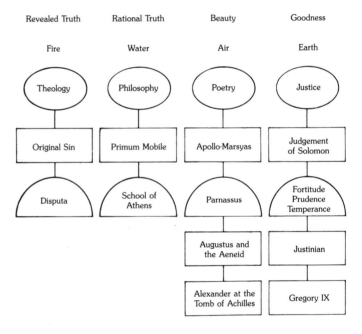

As a whole, the paintings can be considered a synthesis of motifs which illustrate "the agreement between ancient world and Christian spirituality" (Chastel), since they place the virtue of the religious tradition and the spiritual activities of man side by side in a cosmological environment (that is, an environment that refers to the elements which constitute the universe). To achieve this synthesis, Raphael chooses exemplary episodes from the Bible (the Original Sin and the Judgement of Solomon), from classical mythology (Apollo and Marsyas) and from the Aristotelian philosophical conception, reconsidered in the light of humanistic Platonism.

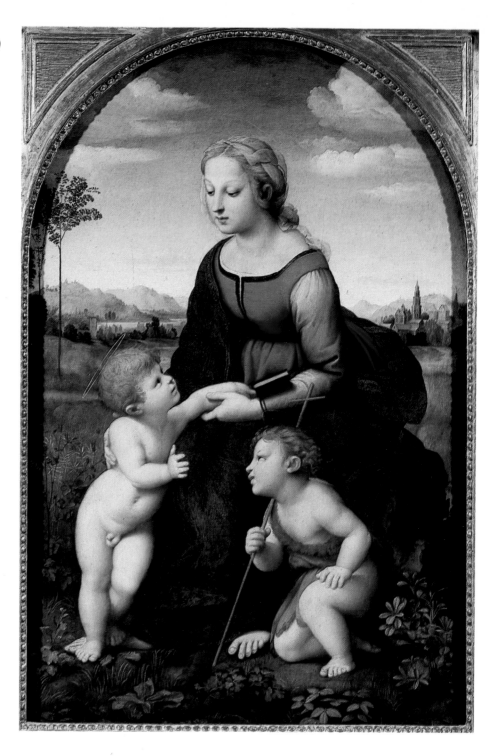

Humanistic-Platonic philosophy, which is basically the thought of Plato adapted to the Christian tradition by the philosophers of the early Renaissance, inspires the entire cycle. According to the most recent studies, the cycle represents the ideas of *Truth* (both the truth revealed by the Christian religion and the rational truth of classical philosophical speculation), *Virtue* (personified by ecclesiastic and civil law and symbolized by the Virtues) and *Beauty* (as it is expressed in poetry).

The realization of the frescoes for the Stanza della Segnatura involved numerous preparatory drawings. These drawings indicate the immense amount of creative energy which underlie the compositions. In fact, Raphael was immediately recognized by the literary figures, thinkers and artists who populated Rome as a personality capable of interpreting the ideas of the intellectual speculation of his time in extraordinarily balanced figurative forms. In the vaults and wall panels, he adapts himself to the work already begun by others. His most original creations are in the large lunettes, where he fully integrates the suggested theme and its formal realization.

The first composition Raphael executed is the so-called *Disputa* or *Disputation of the Holy Sacrament*, the traditional name for what is really an *Adoration of the Sacrament*. The painting is built around the monstrance containing the consacrated Host, located on the altar. Figures re-

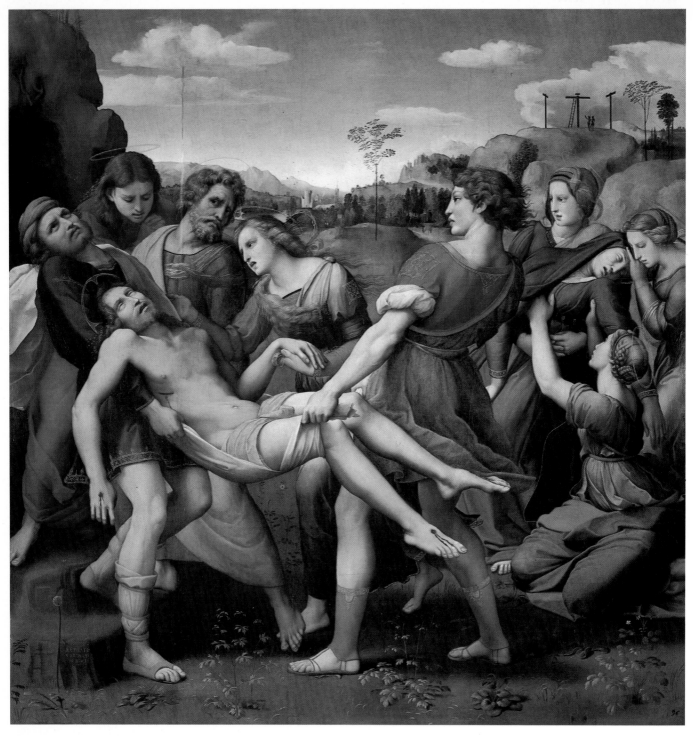

presenting the Triumphant Church and the Militant Church are arranged in two semicircles, one above the other, and venerate the Host. God the Father, bathed in celestial glory, blesses the crowd of biblical and ecclesiastical figures from the top of the composition. Immediately below, the resurrected Christ sits on a throne of clouds between the Virgin (bowed in adoration) and St John the Baptist (who, according to iconographic tradition, points to Christ). Prophets and saints of the Old and New Testament are seated around this central group on a semicircular bank of clouds similar to that which constitutes the throne of Christ. They form a composed and silent crowd and, although they are painted with large fields of color, the figures are highly individuated.

30, 31. The Entombment, with detail
184x176 cm
Rome, Galleria Borghese

32-34. Predella of the Borghese Entombment representing the Theological Virtues
16x44 cm each panel
Vatican, Pinacoteca

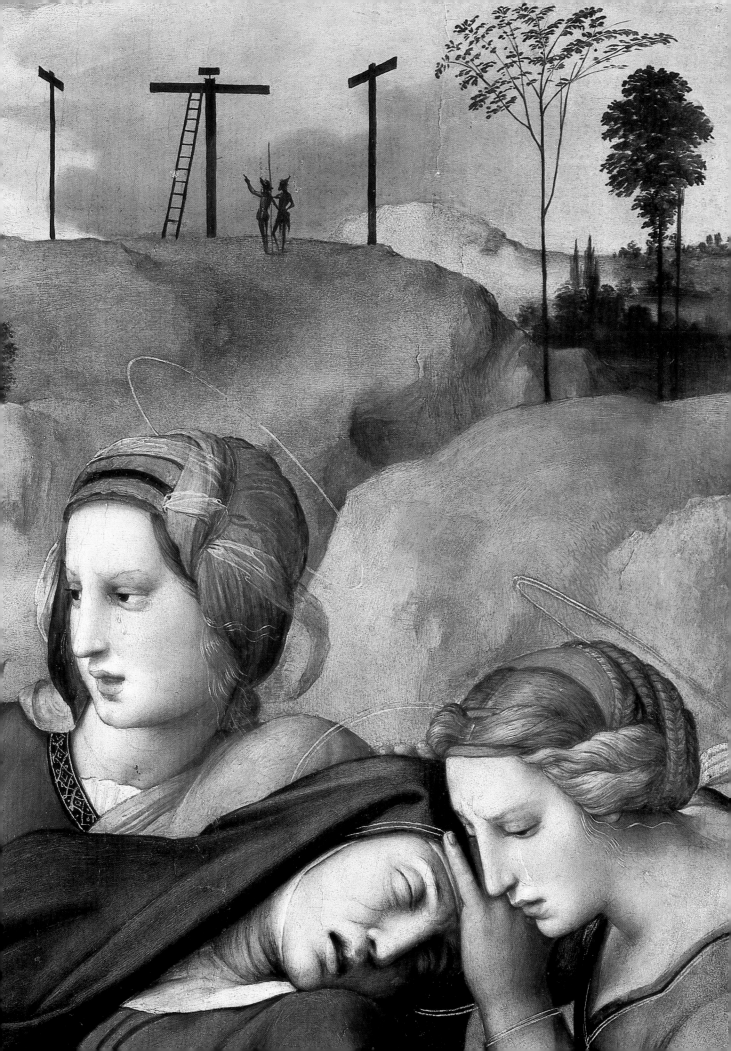

At the bottom of the picture space, inserted in a vast landscape dominated by the altar and the eucharistic sacrifice, are saints, popes, bishops, priests and the mass of the faithful. They represent the Church which has acted, and which continues to act, in the world, and which contemplates the glory of the Trinity with the eyes of the mind. Following a fifteenth century tradition, Raphael has placed portraits of famous personalities, both living and dead, among the people in the crowd. Bramante leans on the ballustrade at left; the young man standing near him has been identified as Francesco Maria Della Rovere; Pope Julius II, who personifies Gregory the Great, is seated near the altar. Dante is visible on the right, distinguished by a crown of laurel. The presence of Savonarola seems strange, but may be explained by the fact that Julius II revoked Pope Alexander VI's condemnation of Savonarola (Julius was an adversary of Alexander, who was a Borgia). The structure of the composition is characterized by extreme clarity and simplicity, which Raphael achieved through sketches, studies and drawings containing notable differences in pose. References to other artists are visible throughout the composition (the young Francesco Maria Della Rovere, for example, possesses a Leonardo-like physiognomy). But the layout, the gestures and the poses are original products of Raphael's research, which here reaches a degree of admirable balance and high expressive dignity.

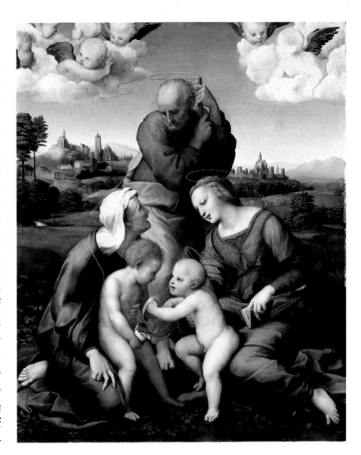

Toward the end of 1509, Raphael began work on the wall opposite the *Disputa*. This second fresco, entitled the *School of Athens*, represents the truth acquired through reason. Raphael does not entrust his illustration to allegorical figures, as was customary in the 14th and 15th centuries. Rather, he groups the solemn figures of thinkers and philosophers together in a large, grandiose architectural framework. This framework is characterized by a high dome, a vault with lacunar ceiling and pilasters. It is probably inspired by late Roman architecture or — as most critics believe — by Bramante's project for the new St. Peter's which is itself a symbol of the synthesis of pagan and Christian philosophies. According to Chastel, it is "the only symbol capable of representing the work of the intelligence".

The figures who dominate the composition do not crowd the environment, nor are they suffocated by it. Rather, they underline the breadth and depth of the architectural structures. The protagonists — Plato, represented with a white beard (some people identify this solemn old man with Leonardo da Vinci) and Aristotle — are both characterized by a precise and meaningful pose. "The horizontal gesture of Aristotle symbolizes the organization of the world through Ethics and the vertical gesture of Plato represents the movement of cosmological thought which rises from the sensible world to its ideal principle" (Chastel). Raphael's descriptive capacity, in contrast to that visible in the allegories of earlier painters, is such that "the figures do not pay homage to, or group around the symbols of knowledge; they do not form a parade. They move, act, teach, discuss and become excited" (Venturi).

35, 36. The Canigiani Holy Family, with detail
132x107 cm
Munich, Alte Pinakothek

33

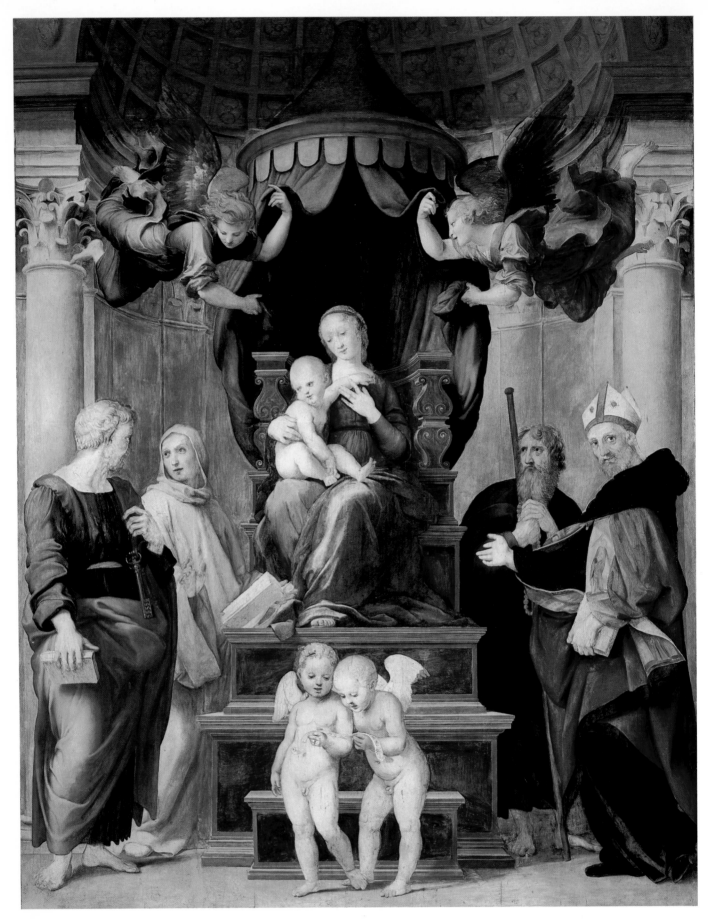

37. Madonna del Baldacchino (after restoration)
276x224 cm
Florence, Galleria Palatina (Pitti Palace)

38. The Mute Woman
68x48 cm
Urbino, Galleria Nazionale delle Marche

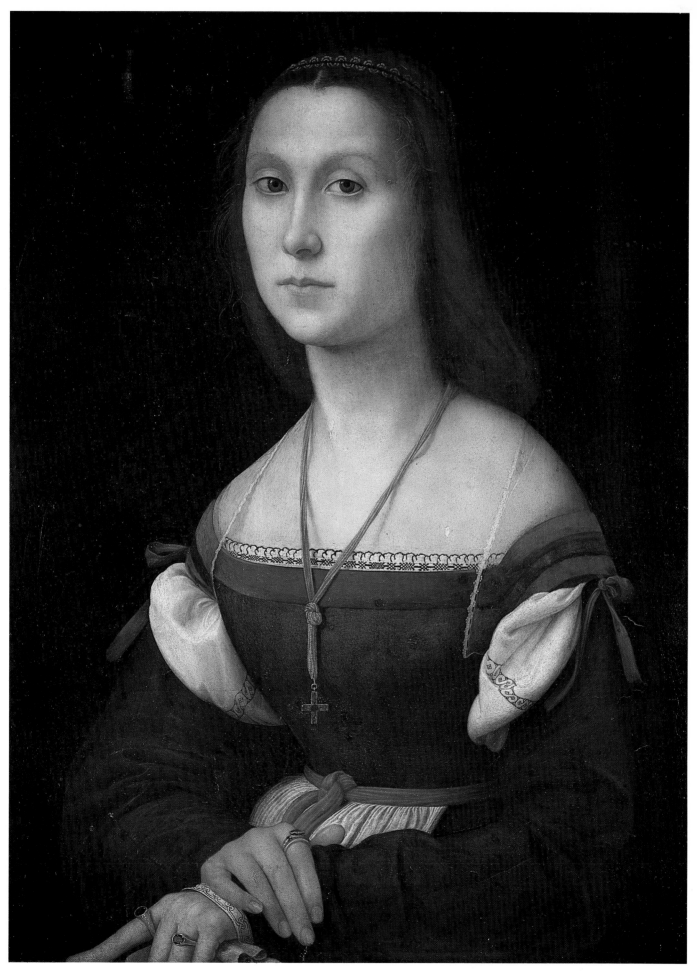

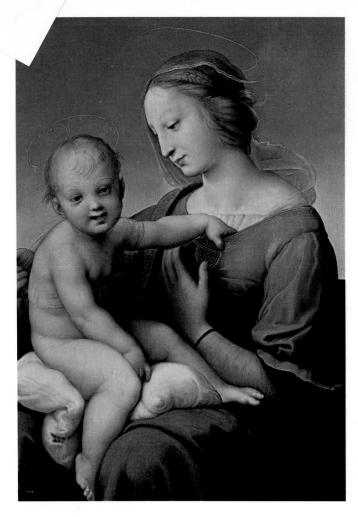

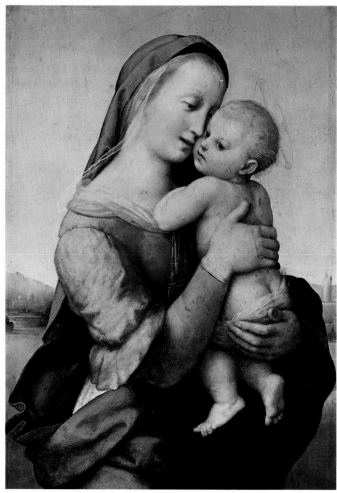

The painting celebrates classical thought, but it is also dedicated to the liberal arts, symbolized by the statues of Apollo and Minerva. Grammar, Arithmetic and Music are personified by figures located in the foreground, at left. Geometry and Astronomy are personified by the figures in the foreground, at right. Behind them stand characters representing Rhetoric and Dialectic. Some of the ancient philosophers bear the features of Raphael's contemporaries. Bramante is shown as Euclid (in the foreground, at right, leaning over a tablet and holding a compass). Leonardo is, as we said, probably shown as Plato. Francesco Maria Della Rovere appears once again near Bramante, dressed in white. Michelangelo, sitting on the stairs and leaning on a block of marble, is represented as Heraclitus. A close examination of the intonaco shows that Heraclitus was the last figure painted when the fresco was completed, in 1511. The allusion to Michelangelo is probably a gesture of homage to the artist, who had recently unveiled the frescoes of the Sistine Ceiling. Raphael — at the extreme right, with a dark hat — and his friend, Sodoma, are also present (they exemplify the glorification of the fine arts and they are posed on the same level as the liberal arts). The fresco achieved immediate success. Its beauty and its thematic unity were universally accepted. The enthusiasm with which it was received was not marred by reservations, as was the public reaction to the Sistine Ceiling.

39. Madonna and Child (The Large Cowper Madonna)
81x57 cm
Washington, National Gallery of Art

40. Madonna and Child (The Tempi Madonna)
77x53 cm
Munich, Alte Pinakothek

Raphael began the third composition for the Stanza della Segnatura at the end of 1509 or the beginning of 1510. It represents *Parnassus*, the dwelling place of Apollo and the Muses and the home of poetry, according to classical myth. Apollo plays a *lira da braccio* (an anachronism which, according to some, was meant to symbolize the perpetual value of the poetic message). He sits under a laurel grove with the nine Muses (who personify the nine types of art). Classical poets are represented in a harmonic ascending and descending movement from left to right. Some of them are portraits of contemporary or historical figures: Petrarch is recognizable in the group in the left foreground; so is Sappho, who holds a scroll bearing her name; Ennius is seated above them, listening to the song of the blind Homer (who appears as a protagonist, like Apollo), behind him stands Dante, who had also appeared in the *Disputa* as a theologist, evidently because of the doctrinal content of the

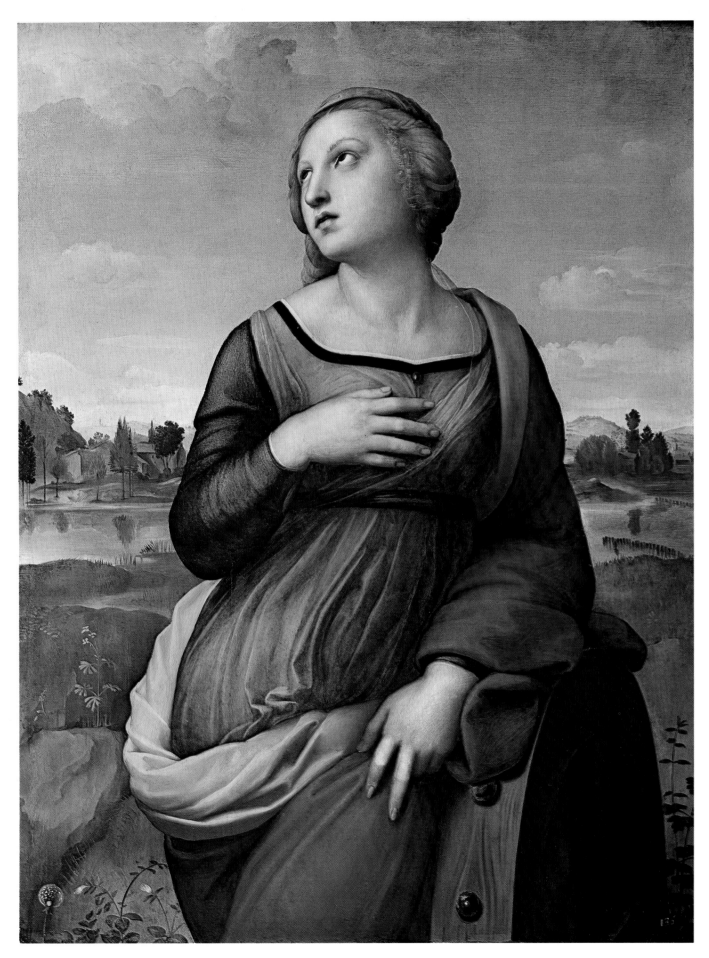

41. St Catherine of Alexandria; 71x53 cm; London, National Gallery

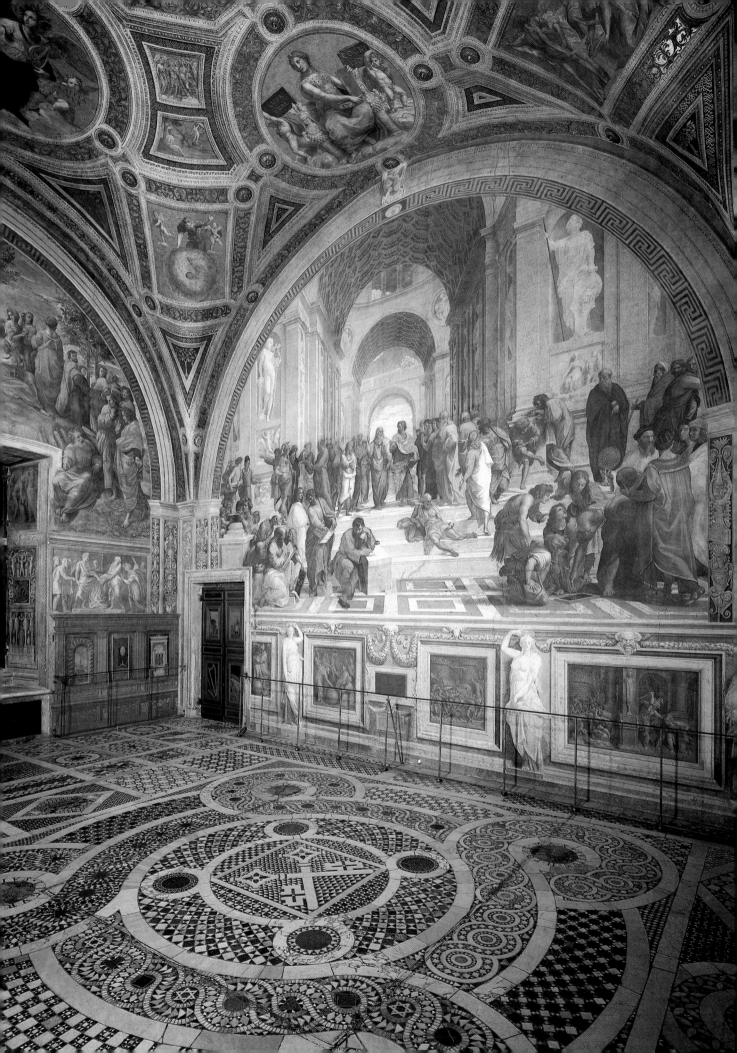

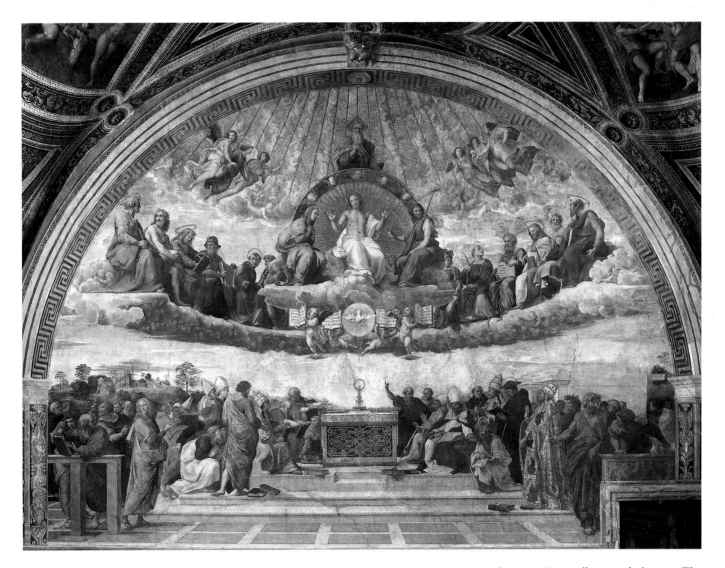

42. *The Stanza della Segnatura in the Vatican Palaces*

43. *Disputation of the Holy Sacrament (La Disputa)*
Vatican, Stanza della Segnatura

44. *The School of Athens*
Vatican, Stanza della Segnatura

Divine Comedy. Some see the portrait of Michelangelo in the bearded figure immediately to the right of the central group, although it is more readily identified with Tebaldeo or Castiglione, for the scene is, after all, a celebration of poetry. Compositional harmony and visual counterpoint characterize the fresco: the groups of figures are bound together by continuous lines and the single characters are represented in opposed but corresponding poses. Although the *Parnassus* lacks the high originality of the *School of Athens*, it demonstrates Raphael's illustrative ability. It is enriched by classical elements which must have held great appeal for a cultural class excited by the recent archaeological discoveries. Thus we must add Raphael's capacity to interpret contemporary taste to his genuine artistic skills.

The lunette containing the *Cardinal Virtues* (which rep-

resent "Good") is built around an allegorical theme. The volumetric modelling of the figures suggests the influence of Michelangelo. The relationship that binds the three figures together is clear and harmonic. Fortitude, dressed in armor, sits in the shade of an oak tree. Prudence is placed on the highest step of the base. She has two faces: one of a young woman who looks at her reflection in a mirror handed to her by a winged putto; the other, of an old man, the symbol of old age, of which prudence is the chief quality. Finally, Temperance is represented holding a pair of reins. The allegory was intended to include the figure of Justice as well. But Justice, being considered superior to the other virtues from a hierarchical point of view, is represented separately in one of the medallions of the vault. Three winged genii symbolize the theological virtues (Charity, gathering the fruits of the oak; Hope, in the center with a flaming torch; and Faith, at the extreme right, pointing toward the sky). Two additional putti complete the composition, "giving the whole scene a free and graceful movement" (De Vecchi).

After the completion of the Stanza della Segnatura, Raphael began the decoration of the adjacent room, afterwards called the Stanza di Eliodoro, after the subject of one of the works painted there. The cycle was painted between

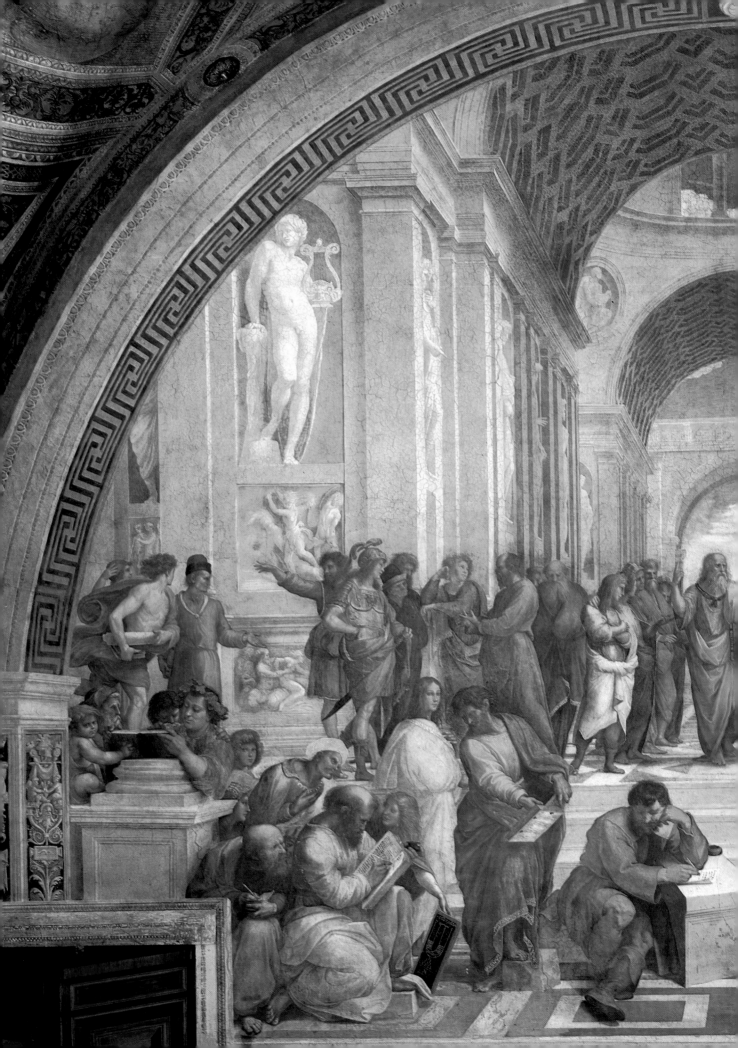

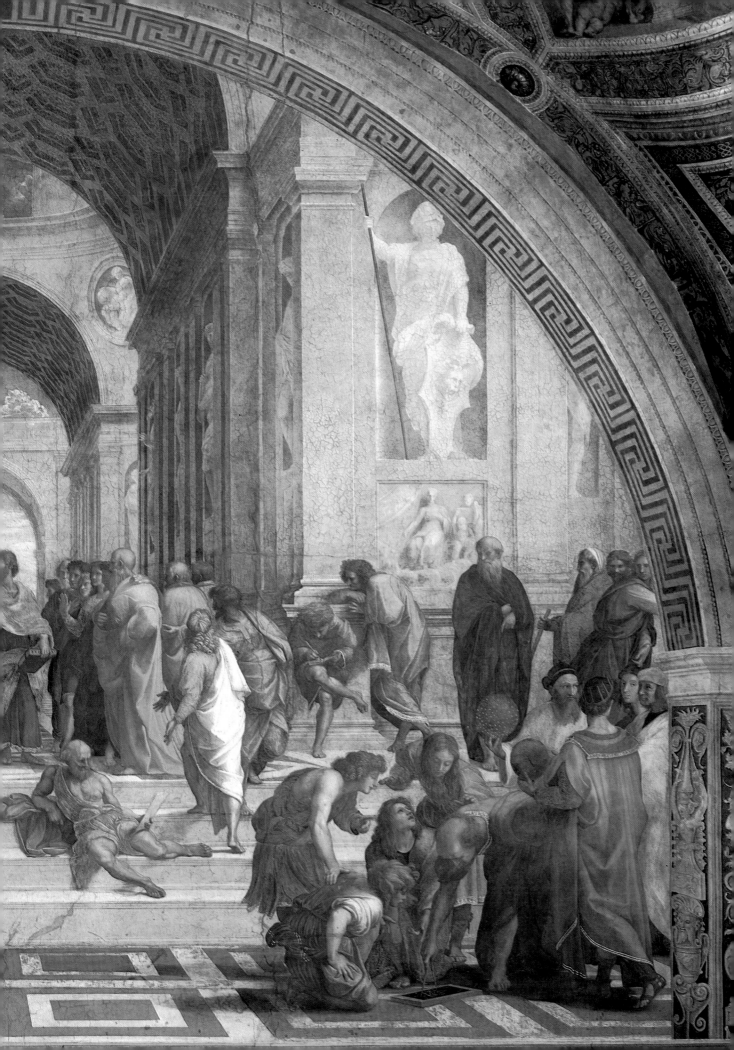

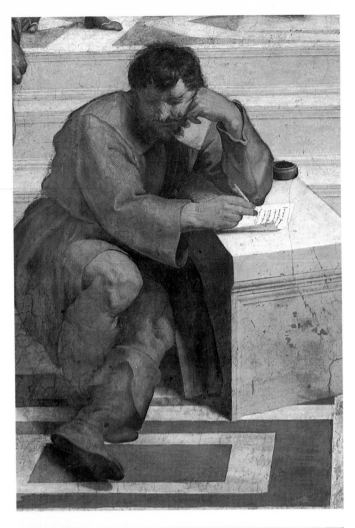

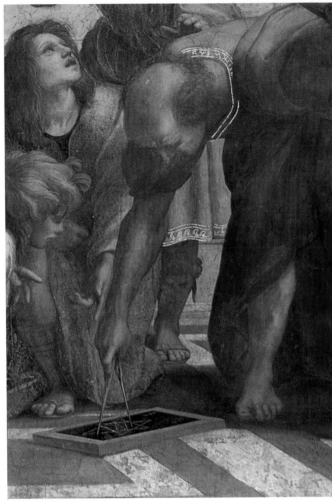

September 1511 and June 1514. Julius II died during this period and his successor, Leo X (Giovanni de' Medici, son of Lorenzo the Magnificent) caused the last scenes to be completed.

In the meanwhile, Raphael had had contact with the art of Sebastiano del Piombo. Sebastiano had come to Rome in 1511 and had worked with Raphael in the villa of the wealthy Sienese banker, Agostino Chigi. The intense colors of the Venetian artist's paintings had attracted Raphael. The result of this contact can be seen in the richer range of color which Raphael used in these scenes.

The vaults of the ceiling represent episodes of divine intervention in the history of Israel (the Burning Bush, the Announcement of the Flood to Noah, Jacob's Dream, the Sacrifice of Isaac). The theme of the room is the presence of God in the history of the Church (including *Heliodorus' Expulsion from the Temple* [Maccabees, 3:24-27] and other episodes). It commemorates the conquest of Palestine by the Hellenistic kingdom of the Syrian Seleucides. The other episodes refer to the Middle Ages (for example, the *Mass at Bolsena* and *Attila's Meeting with Leo the Great*) or to the early years of the Christian Church (e.g., the *Liberation of St Peter*). Therefore the cycle is mainly descriptive. Raphael develops it with those characteristics of dignity and grandiosity which were by then his trademarks. He enhances his compositions by breaking up the symmetry and the en-

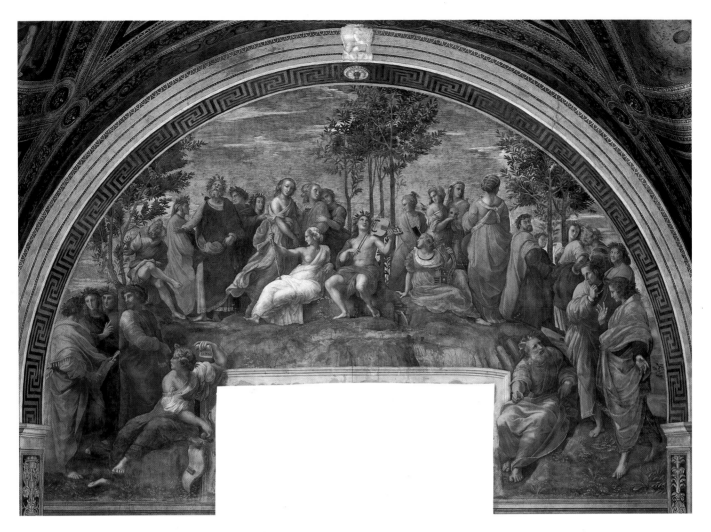

45-47. *The School of Athens,*
details representing Heraclitus with the features of
Michelangelo, Euclid with those of Donato Bramante, and
Pythagoras
Vatican, Stanza della Segnatura

48. *The Parnassus*
Vatican, Stanza della Segnatura

closed rhythm of the Stanza della Segnatura with more lively and colorful effects.

These trends appear first in the *Expulsion of Heliodorus*. The focal point of the scene is no longer at the center. Rather, it is shifted to the right. Here Heliodorus and his followers, profaning the Temple of Jerusalem, are driven out by an armed rider and by two running figures. In the center, the expanse of the wide nave, illuminated by the reflections of light in the vault, is a more effective space-determining motif than the large patches of blue sky which appeared through the coffered ceiling in the *School of Athens*. At the extreme left, Pope Julius II dominates the bystanders, and he reappears in subsequent scenes as well. Raphael's new compositional formula, so unexpected after the extremely controlled compositions of the Stanza della Segnatura, is visible in all its dynamic evidence from this fresco onward.

Another exceptional event is represented after the *Expulsion of Heliodorus*. It is the basis of the Catholic ceremony of the *Corpus Domini*.

In 1263 a priest from Bohemia, during a pilgrimage to Rome, saw blood dripping from the Chalice onto the Corporal cloth while celebrating Mass in Bolsena. This was interpreted as a supernatural answer to the priest's skepticism regarding the transubstantiation. The cloth, as proof of the miracle, was transferred to the neighboring city

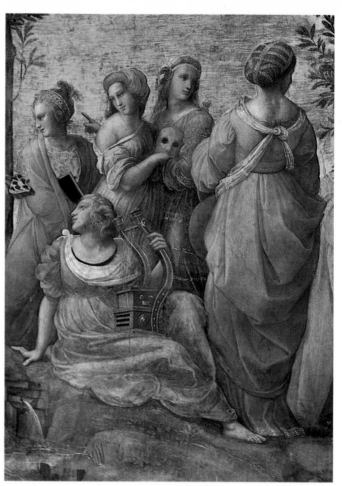

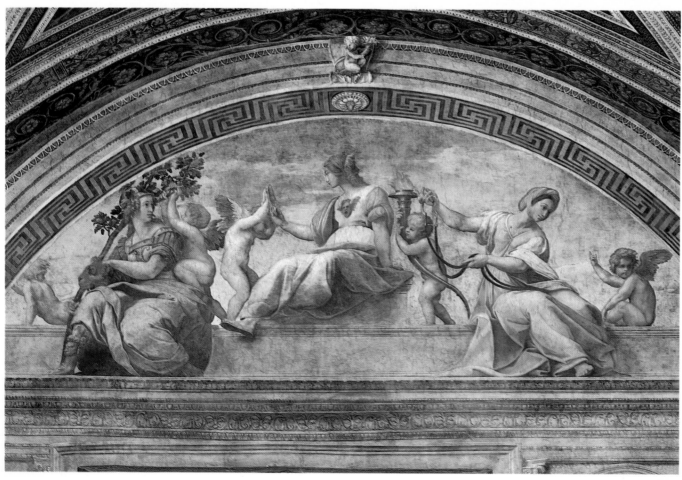

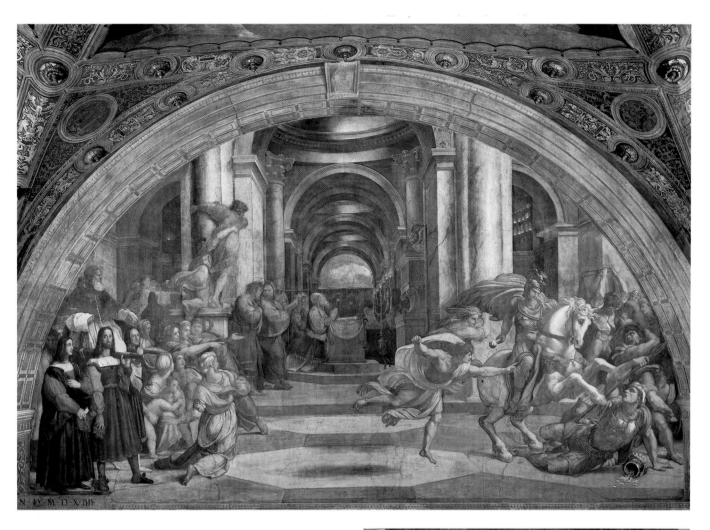

49, 50. The Parnassus,
details representing Dante Alighieri and the Muses
Vatican, Stanza della Segnatura

51. The Cardinal Virtues
Vatican, Stanza della Segnatura

52, 53. The Expulsion of Heliodorus from the Temple,
and detail of the high priest praying for divine aid
Vatican, Stanza di Eliodoro

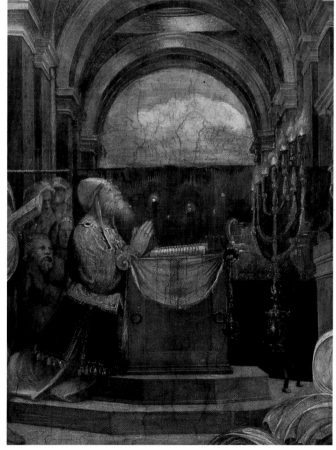

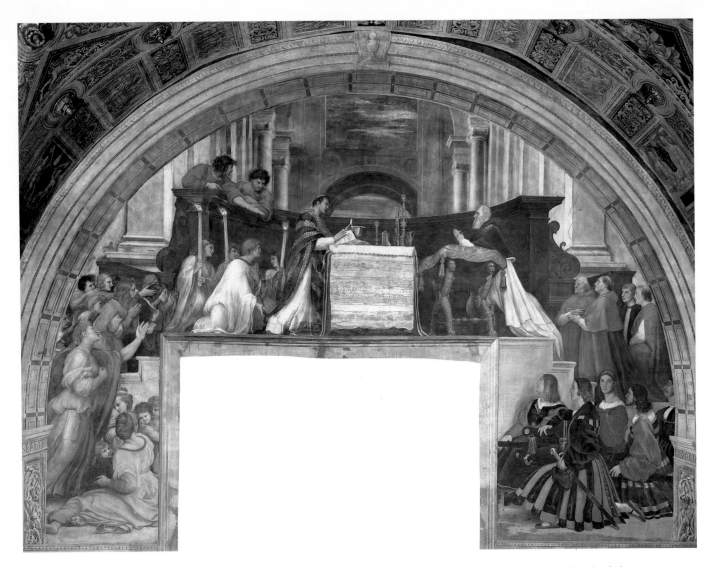

54, 55. *The Mass of Bolsena, and detail of the throne-bearers of Pope Julius II*
Vatican, Stanza di Eliodoro

of Orvieto to be preserved in the Cathedral. The church was rebuilt (in its present form) to honor the occasion. Raphael represents the priest, the protagonist of the event, close to the center of the composition. As he raises the Host, two devotees lean over the semicircular screen which forms the background of the scene. This is a further attempt by Raphael to represent figures in a more dynamic way. Some critics believe he was inspired by Lorenzo Lotto, who was among the artists who had begun to paint the Stanza della Segnatura before his intervention. Pope Julius appears at the right of the scene, a symbol of ecclesiastical authority's presence during, and approval of, the miracle. The Pope's attendants stand one step below and behind him. The asymmetry of the composition regards time as well as space: the excitement of the figures at the left represents a reaction to the supernatural event, which they witness; the stillness of the Pope and his attendants indicates their *spiritual* presence, achieved through a meditative evocation of the event.

Raphael's assistants played a greater role in painting the Eliodoro cycle than in the Stanza della Segnatura. This is clearly a consequence of the growing number of commissions which the Romans granted to Raphael. The hand of Giulio Romano, one of his most faithful pupils, is visible in

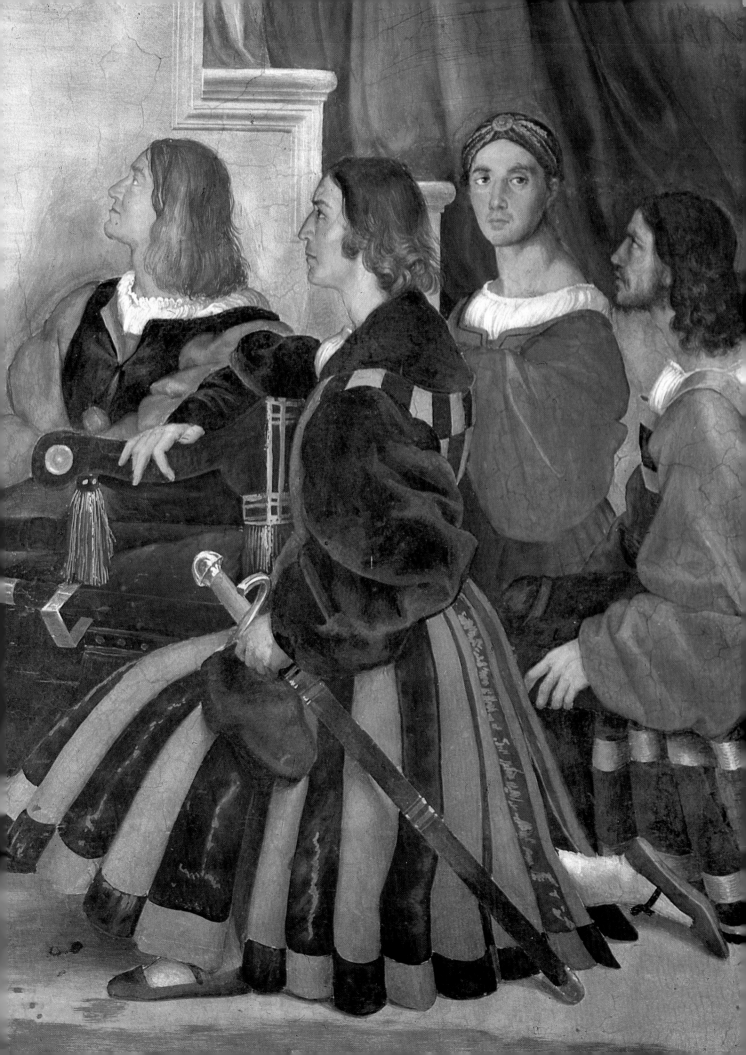

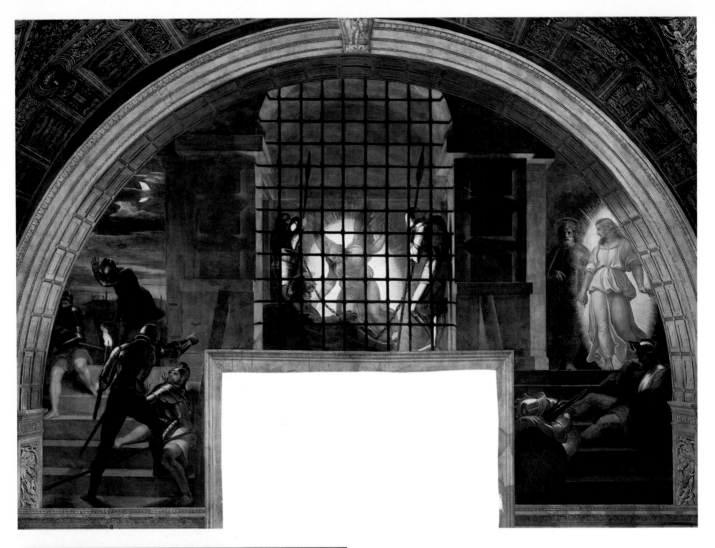

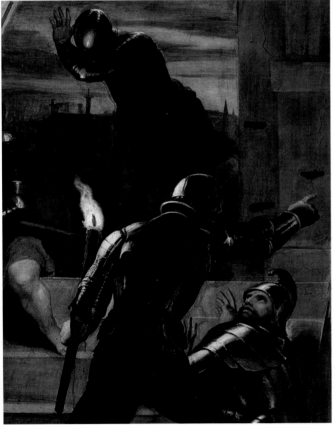

56, 57. *The Liberation of St Peter, with detail*
Vatican, Stanza di Eliodoro

58. *The Meeting between Leo the Great and Attila*
Vatican, Stanza di Elidoro

59. *The Fire in the Borgo*
Vatican, Stanza dell'Incendio di Borgo

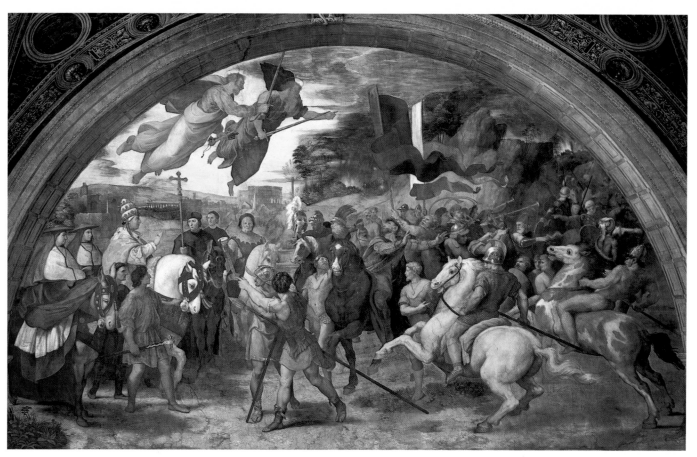

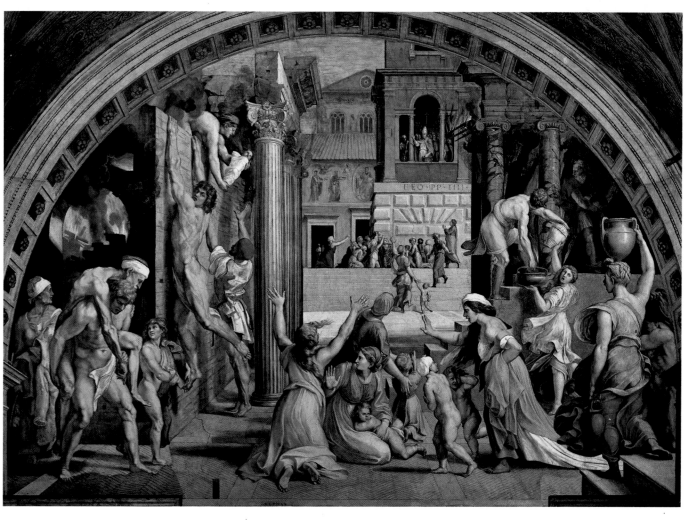

49

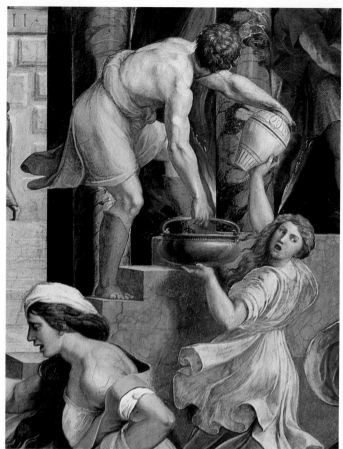

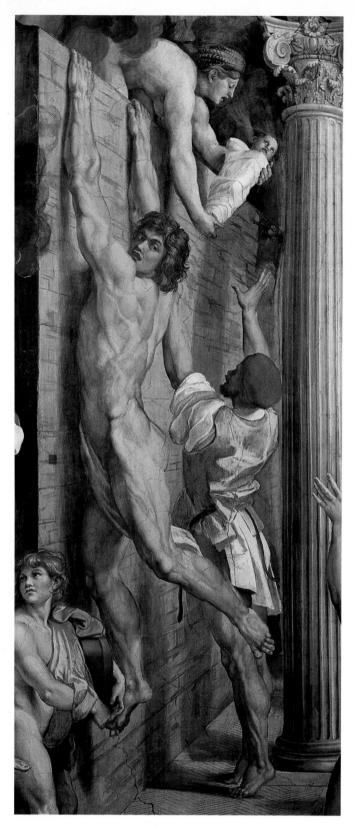

60, 61. *The Fire in the Borgo*, details
Vatican, Stanza dell'Incendio di Borgo

62. *Portrait of a Cardinal*
79x62 cm
Madrid, Prado

the episode showing the *Liberation of St Peter*. The composition of this fresco clearly reflects the order and unity of the *Mass of Bolsena*. But the story is broken down into three distinct episodes, taken from the *Acts of the Apostles*. The first shows the dismay of the guards; the second the appearance of the Angel of Freedom in the saint's cell; the third, the bewildered Peter led by the hand of the divine messenger. The barred cell is on an upper level (like the altar in the *Mass*) and is reached by steps to the left and right. A group of agitated figures occupies the stairway at the left. Here, a soldier — whose armor reflects the light of the moon — asks his sleepy and bewildered comrades what is going on. At right, the angel leads the stunned and still-sleepy St Peter past another sleeping guard. Here, for the first time, Raphael attempts a "night effect", using both the natural light of the moon and the autonomous light of the angel. This painting is the last fresco that can be attributed to Raphael with any certainty. The large cycles which follow (except for the *Sibyls* of Santa Maria della Pace) were entrusted mainly to assistants.

In the last episode of the Stanza di Eliodoro, Raphael returns to the symmetrical compositional type of the Stanza della Segnatura. The painting represents Pope Leo the Great who, with the assistance of God, prevented the Huns from attacking Rome. The figure of the Pope on horseback is a portrait of Leo X. It was originally intended to represent Julius II, but the Della Rovere Pope died before the completion of the cycle, and his portrait was substituted by that of his successor. The scene is divided into two parts: at left

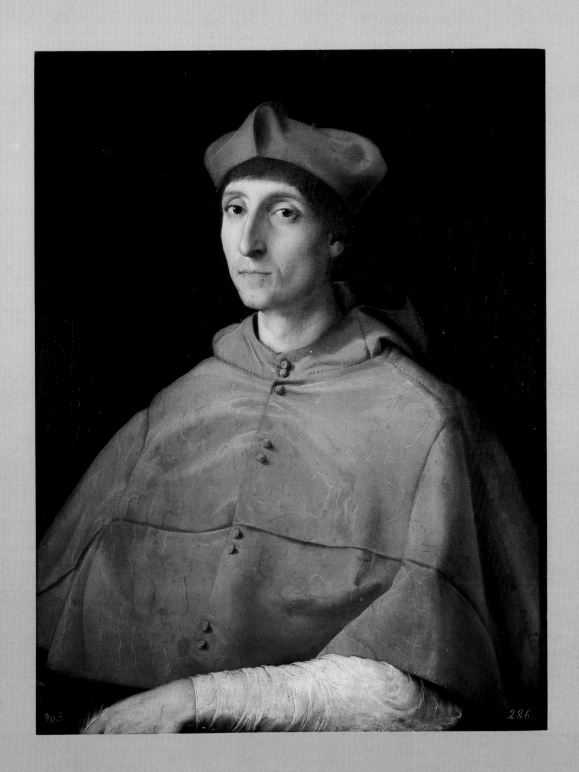

905. 286.

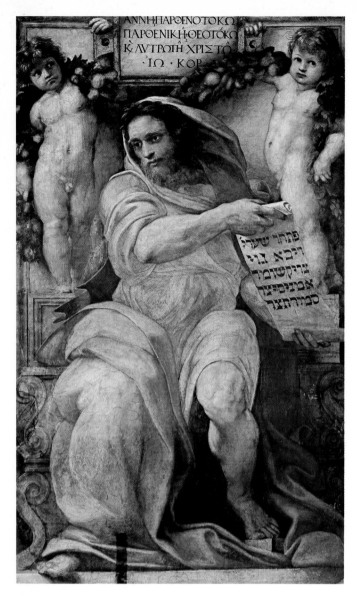

63. The Prophet Isaiah
Rome, Church of Sant'Agostino

64. The Triumph of Galatea
Rome, La Farnesina

the Pope and his attendants, poised and solemn, offer a gesture of peace to the Huns. Above them, Saints Peter and Paul brandish a sword. At right, Attila and his attendants, also on horseback, are frightened to death at the view of the two saints, whose figures are counterbalanced by an armed foot soldier. In the background are Rome and Mount Mario, on which a fire is blazing.

This episode is clearly more fragmentary and dispersive than the other frescoes of the cycle. Many critics attribute this weakness to the extensive participation of Raphael's pupils, led by Giulio Romano.

The room of the *Fire in the Borgo* where, from 1514 to 1517, Raphael's workshop illustrated historical episodes in which the protagonists are the Popes who took the name of Leo, completes our examination of the Vatican cycles. This room contains episodes like the *Fire in the Borgo*, in which a miracle performed by Pope Leo IV caused a fire raging in Rome in 847 to be extinguished; the *Battle of Ostia*, in which the Saracens were lost in a storm at sea, presumably because of the presence of Leo IV, and the *Coronation of Charlemagne* by Pope Leo III on Christmas Day, 799. Here the illustration of themes drawn from the past mixes with the celebration of the political projects of the present Pope, in this case Leo X's reconciliation with France. The fourth subject, the *Oath of Leo III*, anticipates the numerous representations of popes and bishops in assizes which became common during the Counter Reformation in the late 16th century.

The *Fire in the Borgo* is the most complex of the four episodes. It is full of references to classical antiquity, to medieval architecture at the time of the affirmation of the Church, and to themes used by contemporary artists. It celebrates the intercession of Leo IV, by whose grace a fire which spread through the Borgo, a popular section of Rome near the Basilica of St Peter, was extinguished. The structure of the composition is complex: two colonnades of clear classical derivation define a square. The Pope, who again bears the features of Leo X, blesses the frightened crowd from a gallery located beyond the colonnades. The façade of old St Peter's appears behind him, in the background. The term 'scenographic' can appropriately be applied to this painting. Clearly, Raphael was concentrating on richer, more varied, but less harmonious compositional solutions than those of his previous paintings. The figure groups express great formal beauty, but they lack harmonious relationships and remain pure examples of episodical representation. The group in the left foreground, for example (made up of an old man on the shoulders of a young man, and a child), may be drawn from the episode of the *Aeneid* in which Aeneas escapes with his father, ANchises and his son, Ascanius. The woman with children in the center of the fresco and the water carrier at right, whose clothes blow in the wind, represent similar stereotypes. The nude descending from the wall at left recalls the heroic figures of Michelangelo. Notwithstanding these limitations, the scene is highly effective and demonstrates Raphael's skill as an illustrator, although, as the critics maintain, it was executed largely by his pupils.

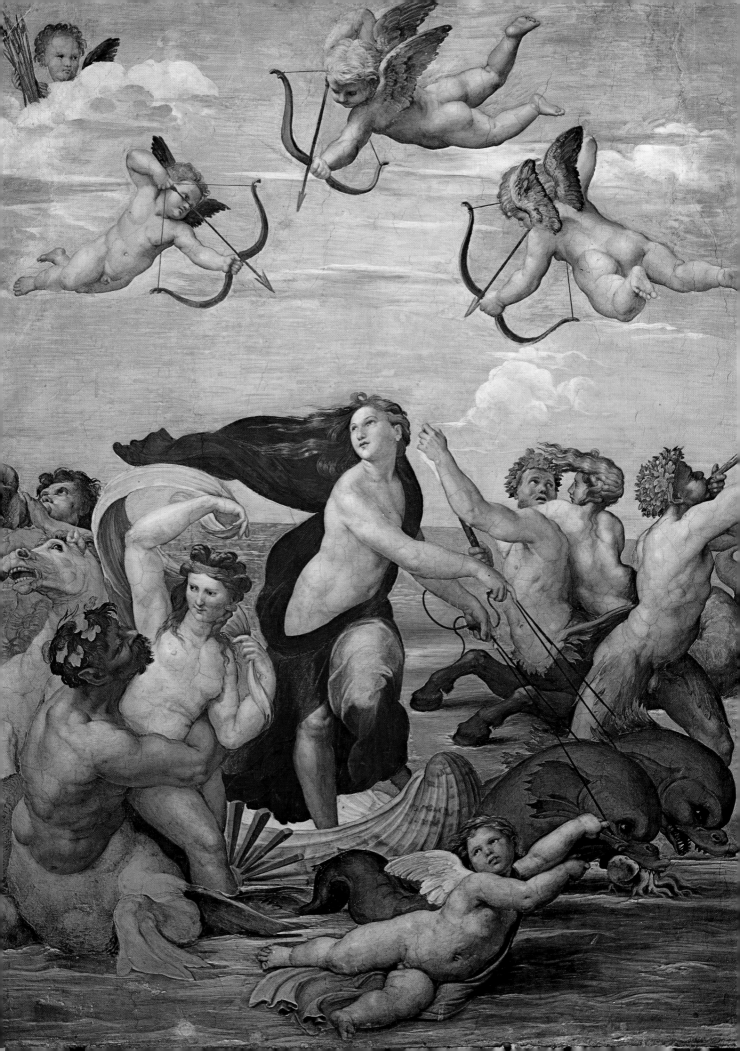

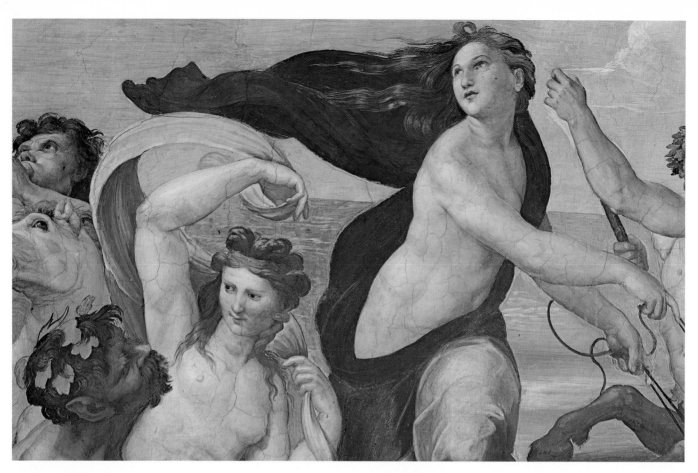

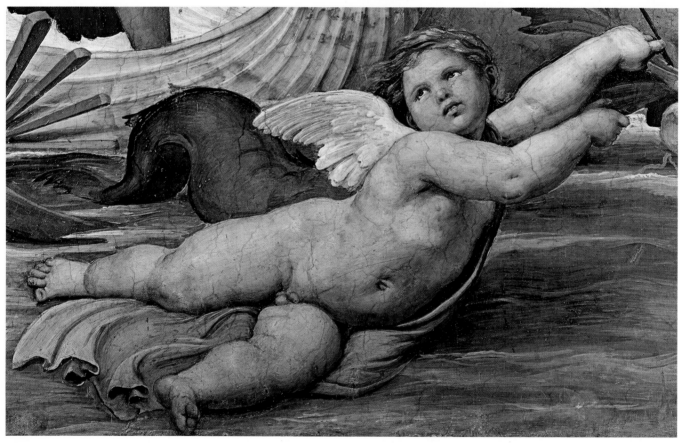

65, 66. The Triumph of Galatea, details
Rome, La Farnesina

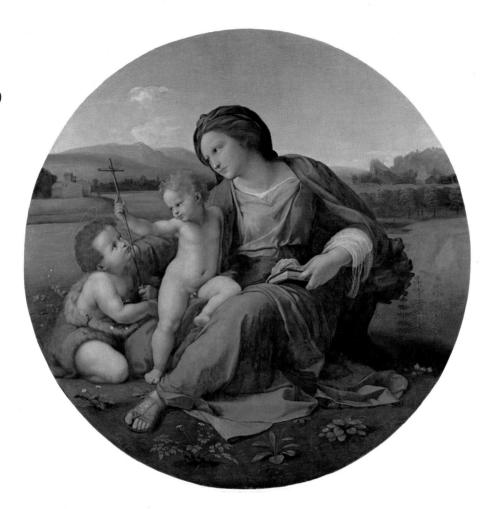

67. Madonna and Child with the Young St John (Madonna del Duca d'Alba) dia. 98 cm Washington, National Gallery of Art

Raphael after the Vatican Stanze

The fame of his fresco cycles brought Raphael numerous other commissions in Rome. Some of these were executed at the same time as the monumental cycles of the Vatican Stanze.

One of the masterpieces of this period is the *Portrait of a Cardinal* today in the Prado in Madrid. This painting was once considered a work of the mature painter. But it has recently been dated 1510-1511 on the basis of its composition which resembles those of the *Portraits of Agnolo and Maddalena Doni* and the *Mute Woman*. The pose is identical: the figure is turned three-quarters out and the arm nearest the viewer defines the lower limit of the picture space.

Raphael returns to the representation of the Virgin and Child with St John in the *Madonna del Duca D'Alba*. The composition of this tondo is extremely simple. The pyramidal scheme is expanded in width. The cold and resonant colors contrast with the delicate greens and light-blues of the broad landscape background. Small, symmetrically arranged flowers provide centers of color against the ochre tones of the ground. The Virgin's eyes are symbolically fixed on the cross made of sticks which St John (who is the precursor of Christ) and the infant Christ both hold. The vigorous modelling of her drapery may be inspired by Michelangelo. But, as Venturi notes, "the pure features, the radiant open eyes, translate the solemn... language of Michelangelo into the melodic language of Raphael". The work is roughly dated 1511.

The Sienese Banker, Agostini Chigi, played a very important role in the cultural and artistic activities which flourished around Julius II. His house was built on the outskirts of Rome in 1509-1510, and was designed as a model of luxury and elegance. He commissioned the most famous artists of the time, Baldassarre Peruzzi, Sebastiano Luciani (later called Sebastiano del Piombo) and Raphael himself to decorate it. All three painted frescoes based on classical mythology in Chigi's house (which was later acquired by the Farnese family and came to be known as "La Farnesina"). Raphael illustrated a theme from the Greek poet, Theocrates, on the walls of the Loggia (or porch), in a painting which combines the vitality of pagan narrative with his unusual compositional harmony. Galatea, the sea-nymph, rushes forward on a dolphin-drawn chariot. Her head is turned to one side and her glance is directed over

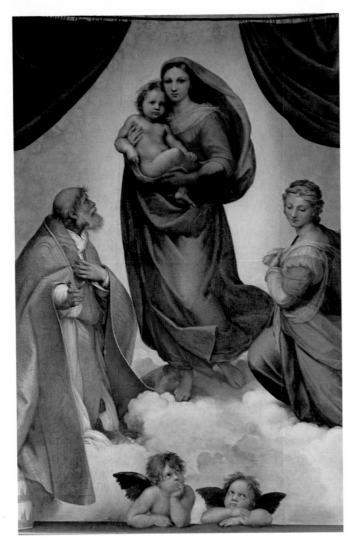

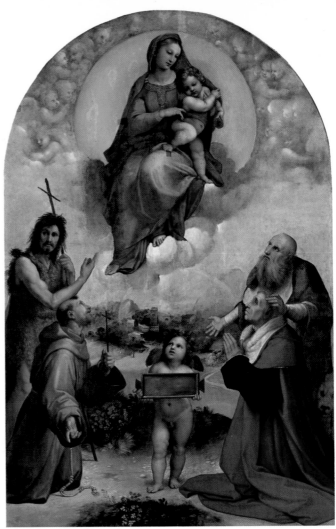

her shoulder toward the *amorini* or cupids who fly above her, bows drawn. A crowd of sea-nymphs and Tritons — fantastic creatures, half man and half fish — surround her. The powerful nudes possess the energy of Michelangelo, but the soft modelling of the winged cupids is peculiar to Raphael.

Agostino Chigi later commissioned other works to Raphael: the *Psyche*, also in the Farnesina; the *Sibyls* in the Church of Santa Maria della Pace; and the tondo in the Church of Santa Maria del Popolo.

A new fresco occupied Raphael during the period 1511-1512: the *Prophet Isaiah* painted for Johannes Goritz of Luxemburg, Head Chancellor of the Papal Court. That the work was commissioned by a foreigner is indicative of the extraordinary fame that Raphael had acquired. This powerful but composed prophet and the putti who surround him echo Michelangelo's figures in the *Sistine Ceiling*. Nonetheless, the putti, whose glances and poses are enlivened by a strong spiritual tension, are transformed by Raphael into tender and formally controlled children. Even the action of the wind that blows Isaiah's mantle is a life-giving device rather than an expression of dramatic feeling. The dedicatory inscription in Greek (which alludes to St Ann, patron of Goritz) and the Hebrew scroll which the

68. The Sistine Madonna
265x196 cm
Dresden, Gemäldegalerie

69, 70. The Madonna of Foligno, with detail
320x194 cm
Vatican, Pinacoteca

Prophet holds, reflect the learned environment in which the work was conceived.

The solemn forms of the Vatican Stanze, the Farnesina frescoes and the *Isaiah* appear again in two large panels representing the Madonna in Glory. The first was executed for Sigismondo de' Conti in 1511-1512 and is usually called the *Madonna of Foligno*. The second, dated 1513-1514, is called the *Sistine Madonna*.

Raphael's pictorial research had been enriched by his solutions regarding the use of light in the *Expulsion of Heliodorus* and the *Liberation of St Peter*. These pictorial devices reappear in the *Madonna of Foligno*, now in the Vatican Museum. The Madonna and Child, borne by a cloud of angels and framed by an orange disk, dominate the group of saints below them, among whom is the donor. This group

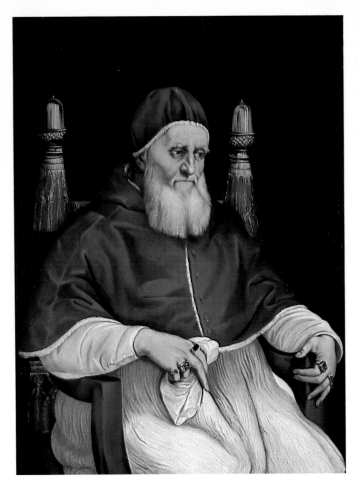 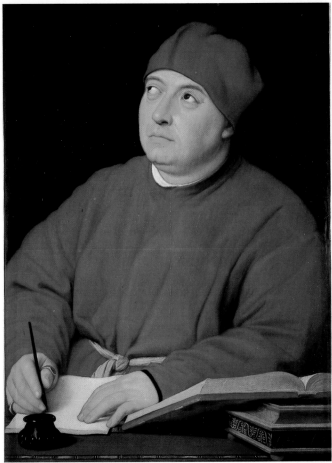

includes — from left to right — *St John the Baptist, St Francis, Sigismondo de' Conti and St Jerome*. A small angel at the center of the composition holds a small plaque which was originally intended to carry the dedicatory inscription. The painting was commissioned to commemorate a miracle in which the donor's house in Foligno was struck by lightning or — according to another version — was struck by a projectile during the seige of Foligno, although it was not damaged. The stormy atmosphere of the landscape background and the flash of lightning (or explosion) which strikes the Chigi Palace (visible at left) illustrate the legend. The strong characterization of the figures, the volumetric fullness of the putti and the refined *chiaroscuro* distinguish the panel (which was taken as loot by Napoleon's army in 1799 and returned in 1815) as a work of the mature artist.

The canvas with the Virgin, Child and Saints Sixtus and Barbara, usually called the *Sistine Madonna* (now in the Dresden Museum), is characterized by an imaginary space created by the figures themselves. The figures stand on a bed of clouds, framed by heavy curtains which open to either side. The painting was probably intended to decorate the tomb of Pope Julius II, for the holy Pope Sixtus was the patron saint of the Della Rovere family and St Barbara and the two winged *genii* (visible at the bottom of the picture space) symbolize the funeral ceremony. The canvas was located in the Convent of St Sixtus in Piacenza and was later donated by the monks to Augustus III, King of Saxony. It was carried to Moscow after the Second World War, and

was later returned to Dresden. The Virgin actually appears to descend from a heavenly space, through the picture plane, out into the real space in which the painting is hung. The gesture of St Sixtus and the glance of St Barbara seem to be directed toward the faithful, whom we imagine beyond the ballustrade at the bottom of the painting. The Papal tiara, which rests on top of this ballustrade, acts as a bridge between the real and pictorial space.

The Pope who had commissioned the pictorial cycles and the works that had so contributed to the artist's fame, is depicted — according to historical sources, in the master's hand — in a portrait "so animated and true to life that it was frightening to behold, as though it were actually alive" (Vasari). The original painting was intended for the Church of Santa Maria del Popolo in Rome, but never arrived there. The Uffizi canvas is a copy which arrived in the Medici collections in Florence from Urbino with the Della Rovere inheritance. Attributed by critics to 1512, it shows the Pope seated with the tiara on his head, dressed in a white surplice and a purple mantle. Here the simple but effective tonal contrast, first used in the *Portrait of a Cardinal*, reappears. The Pope, though old, still seems very vigorous and the Della Rovere energy is clearly visible in the hand that grasps the right arm of the chair with strength and pride. The two acorn-shaped knobs on the back of the chair recall the Pope's coat of arms. The intimacy of the image, although weakened by the executor of the copy, indicates that Raphael has progressed from the narrative compositions of

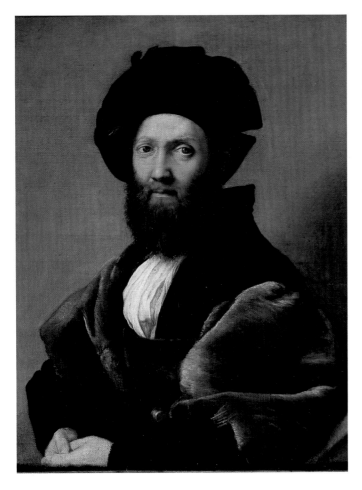

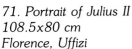

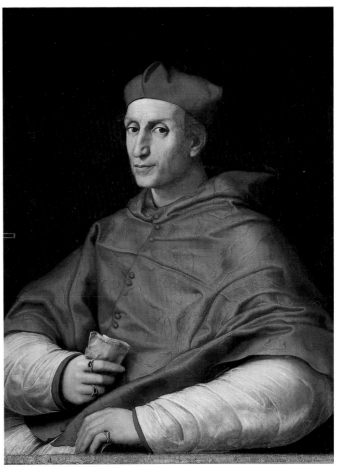

71. *Portrait of Julius II*
108.5x80 cm
Florence, Uffizi

72. *Portrait of Fedra Inghirami*
89.5x62.3 cm
Florence, Galleria Palatina (Pitti Palace)

73. *Portrait of Baldassarre Castiglione*
82x67 cm
Paris, Louvre

74. *Portrait of Cardinal Bibbiena*
85x66.3 cm
Florence, Galleria Palatina (Pitti Palace)

the Vatican Stanze to the full dominance of individual subjectivity.

Meanwhile, Raphael had passed from the highly synthetic and expressive compositions of the first years of the decade to representations which were more and more complex and even more dispersive. Most of these were also finished by his pupils, for, as we mentioned above, this was the busiest moment in Raphael's career.

The *Madonna dell'Impannata* in the Pitti Gallery in Florence was also painted with the help of assistants. According to some critics, the assistants executed the entire painting.

But others see the master's hand at least in the major figures (some say in the Christ child, some in St Elizabeth, some in both figures). The composition is innovative in respect to the usual iconography of the holy family. It shows St Catherine, St Elizabeth, Christ, the Virgin and St John gathered together in a group. A large tent is visible in the background and a window covered by linen (the *impannata*, or cloth covering of a window, which gives the painting its name) can be seen at the extreme right. Like many other works by Raphael, this painting was carried off by the French in 1799 and was not returned until after the Congress of Vienna, in 1815.

In 1514 Raphael executed another small but significant fresco cycle for Agostino Chigi. The frescoes represent the *Prophets and Sibyls*. They are located in the chapel at the left of the apse of the Church of Santa Maria della Pace in Rome. The figures occupy a trabeated loggia, on two levels. The structure of the loggia reflects the architecture of the chapel: its arches coincide with those of the window and entrance. The *Prophets* (Habakkuk, Jonah, David and Daniel, according to the most widely accepted interpretation) are generally attributed to a collaborator (perhaps Timoteo Viti) who must have based them on an original drawing by Raphael, for they are highly coherent. The *Sibyls* (Cumaean, Persian, Phrygian and Tiburtine) are attributed to Raphael. Like the Virtues in the Stanza della Segnatura, each of the figures is accompanied by an angel who indicates the divine spirit present in their prophecies.

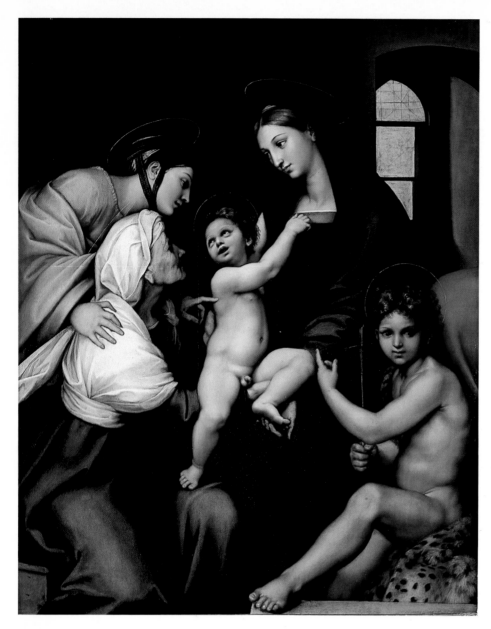

Between the Sibyls at the top of the arch is a small angel holding a lighted torch, the symbol of prophecy, which enlightens the darkness of the future.

Raphael probably accompanied Leo X when he went to Bologna to meet the King of France, Francis I, in 1515. He may have passed through Florence, where Leo was welcomed with great enthusiasm by his fellow citizens. Leonardo da Vinci — who later accepted the French King's invitation to Paris — and Michelangelo — to whom Leo X commissioned the New Sacresty of San Lorenzo — also followed the Pope.

A letter which Raphael sent to the painter, Francesco Francia, provides proof of this journey. According to a legend, Francesco Francia died after seeing the St Cecilia which Raphael painted for the Church of San Giovanni in Monte in Bologna. The story is almost credible, for the Bolognese artistic environment still revolved around the style of Perugino. The painting, which is now in the Museum of Bologna, was placed in San Giovanni in Monte in 1515. It was painted some time before, however. The figures re-

present St Paul, St John the Evangelist, St Cecilia, St Augustine and St Mary Magdalene. The four saints who surround the protagonist form a niche which is strengthened by the poses and gestures of the figures (the glances of the Evangelist and St Augustine cross, St Paul's is lowered and the Magdalene turns hers toward the spectator). Only St Cecilia raises her face toward the sky, where a chorus of angels appears through a hole in the clouds. The monumentality of the figures, typical of Raphael's activity during this period, dominates the other figurative elements. The still life of musical instruments on the ground has been attributed to Raphael's pupil Giovanni da Udine, according to a tradition begun by Vasari.

The Madonna della Sedia, in the Pitti Gallery in Florence, was probably painted during the period immediately after the completion of the Stanza di Eliodoro. The qualities of color and light which this tondo possesses result in great compositional harmony. A circular motif dominates the painting, in perfect agreement with the form of the support. The Virgin is by no means conceived in aristocratic terms.

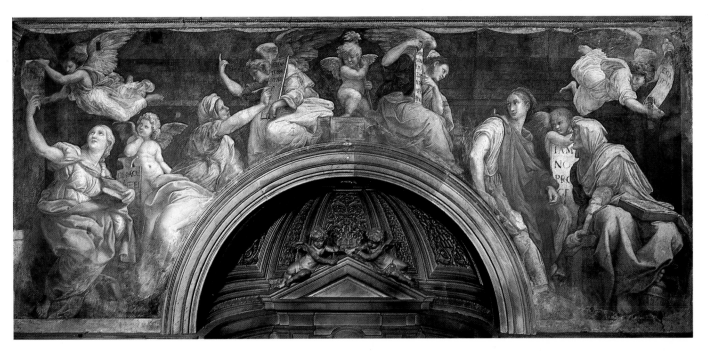

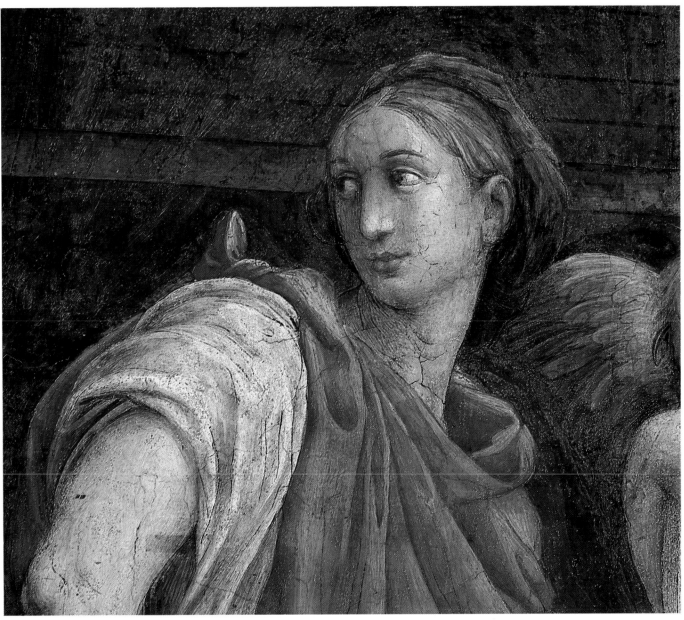

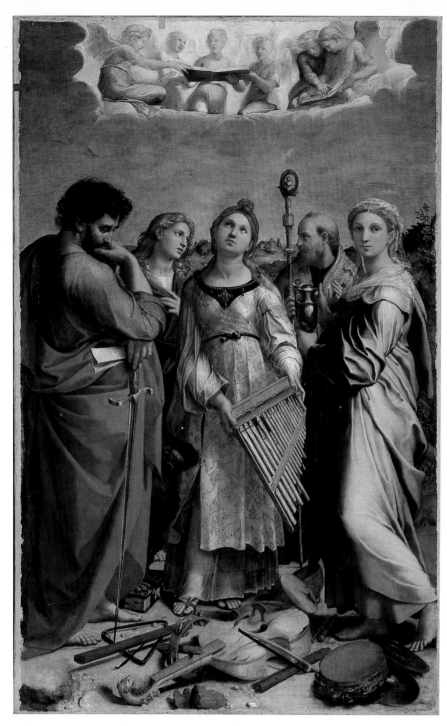

78. St Cecilia
238x150 cm
Bologna, Pinacoteca Nazionale

79. Madonna and Child with the Young
St John (Madonna della Sedia)
dia. 71 cm
Florence, Galleria Palatina (Pitti Palace)

Her clothes are modest, and even the maternal sentiment expressed in the painting is not altered by the knowledge of its sacred nature. Rather, it is expressed in an instinctive gesture of affectionate protection of the Child. The rich and polished back of the chair which gives the work its name (*sedia* means chair) thus stands in clear contrast to the figure. The young St John fills the space left free by Virgin and Child and balances the composition, though remaining outside the tender relationship which links mother and Child.

Many critics associate the composition of the *Madonna della Sedia* with that of the *Madonna della Tenda* (so called because of the curtain which forms the background) in the Alte Pinakothek of Munich. Here again the Madonna is

shown in a three-quarters view with the Child and the young St John. But a relationship exists among the figures which is absent in the *Madonna della Sedia*. The Virgin smiles at her Child, whose attention is turned toward St John. The face of the latter bears an expression of loving devotion. By comparing Raphael's mature works to one another, one detects a process of continuous growth, of stylistic evolution. The elements used are always new, as is the pictorial style. But the master's extraordinary capacity to harmonize the composition and the formal beauty of the figures, made more evident by the expression of serene emotion, are unifying motifs.

There are two extant versions of Raphael's *Portrait of Cardinal Inghirami:* one in Boston and the other in Palazzo

Pitti. Each has been considered the original at one time or another, but the dispute is useless, since both are highly coherent and the differences between them are slight: the physical structure of the Cardinal is more massive in the Boston portrait and leaner in the Pitti one. The red of the Cardinal's clothing dominates both. Inghirami's crossed eyes, a physical defect which the artist does not leave out, acquire a discreet tone which almost dissolves in the inspired pose of the figure. Without idealizing, but also without falling into unpleasant naturalism, Raphael maintains a harmonic equilibrium between realism and dignified celebration, a primary characteristic of portrait painting.

The *Portrait of Baldassarre Castiglione* (now in the Louvre), a literary figure active at the court of Urbino in the early years of the 15th century and author of the *Courtesan*, the book which summed up the tastes and culture of the Renaissance, may or may not have been painted by Raphael. According to a letter of 1516 from Pietro Bembo to Cardinal Bibbiena, "The Portrait of M. Baldassar Castiglione... [and that of Duke Guidobaldo di Montefeltro] would seem to be by the hand of one of Raphael's pupils". But the high quality and masterful combination of pictorial elements which distinguish the painting (note the affection inherent in the intelligent and calm face of Castiglione) lead one to believe that the master participated in some way in its execution. Certainly the shaded tonalities of the clothing and the unusually light background indicate the hand of a skillful and experienced painter.

80. *Madonna and Child with the Young St John*
(Madonna della Tenda)
68x55 cm
Munich, Alte Pinakothek

Also in 1516, Agostino Chigi commissioned the decoration of his chapel in Santa Maria del Popolo to Raphael. Raphael designed the architecture of the chapel and planned Agostino's tomb. He prepared the cartoons for the mosaic of the dome, fusing together classical motives (the Planets, represented as pagan gods) and Christian ones (the figure of God the Father who sets the heavens in motion with an authoritative gesture). But his activity in this year included other works as well. He was widely recognized at the humanistic court of Leo X, who made him the architect of St Peter's on 1 August 1514, and this increased his work load. He was placed in charge of the marble which came to St Peter's from excavations and from antique monuments. He gathered statues, medals and antique objects for Alfonso I d'Este. Finally, he tried his hand as a sculptor. The largest task he undertook in the course of the year was the preparation of the cartoons for the tapestries for the Sistine Chapel depicting the *Stories of Saints Peter and Paul*. The completed tapestries were acquired by Charles I, King of England, and are now in the Victoria and Albert Museum in London.

The *Donna Velata* in Palazzo Pitti is another portrait dated 1516. Tradition identifies the subject with "la Fornarina", the woman whom the painter loved in his last years and whose face reappeared in both his paintings and those of his followers. The painting shows greater attention to color and to the rendering of skin and clothes in respect to previous female portraits. The regular oval of the young woman's face stands out against the dark background and her eyes hold an intense and penetrating look. The silk of her sleeves contrasts with her ivory-like skin, and is closely associated with the thin pleating of the dress, held up by a corset with golden embroidery. As in the portrait of Castiglione, the figure radiates a sense of great dignity and restraint. But greys and light-blues dominated the portrait of Castiglione: here the warm tonalities of white and gold take over. Raphael is preparing the wider color range and the more complex composition which will be expressed in the *Portrait of Leo X*.

During this period Raphael was much sought after by priests and cardinals who competed in the decoration of their mansions in Rome. Cardinal Bernardo Dovizi da Bibbiena, a cultured playwright, and (like Leo X) a passionate scholar of classical antiquity, undoubtedly had more contact with Raphael than any of his colleagues. Raphael painted a portrait of the Cardinal which clearly expressed his shrewd and malicious spirit and his taste for beautiful things and fine living. The attribution of the portrait (now in the Pitti Gallery) is not certain, but the composition and the characteristic use of white and red suggest Raphael's hand. However, the rendering seems more rigid than in the paintings certainly painted by Raphael. Some critics therefore attribute it to a pupil of Raphael, or suspect that it may be a copy of an original which might have been lost. The Cardinal was so close to the artist that he offered his niece, Marietta, in marriage.

In the same year as the *Portrait of Cardinal Bibbiena* (1516), Raphael and his followers were commissioned to decorate the bathroom of the Cardinal's Vatican apartments, the so-called *Stufetta*. The ornamental motives employed in the *Stufetta* paintings derive from those of the *Domus Aurea*, the villa of the Emperor Nero situated between the Palatine and the Velian hills. The *Domus Aurea* had recently been rediscovered. By 1516 it had become an object of great enthusiasm for contemporary artists. The names of Giovanni da Udine, Domenichino and other lesser known painters are still visible, scratched in the walls of the monument. Raphael painted the *Story of Venus* on the walls of the *Stufetta*, perhaps at the suggestion of the Cardinal. He represented the episodes of the story in the same techniques used in the *Domus Aurea*: stucco and fresco. The decoration of the borders started a new ornamental style, called "grottesque", which derives from the decoration of the "grotto" of Nero's villa. The new style was widely used throughout the Cinquecento and after. It replaced the "candelabro" motif of the Quattrocento, generally made up of plants, animals and stylized putti growing out of a vase or amphora. Raphael thus left his mark in the field of decorative tastes as well as in that of pictorial style.

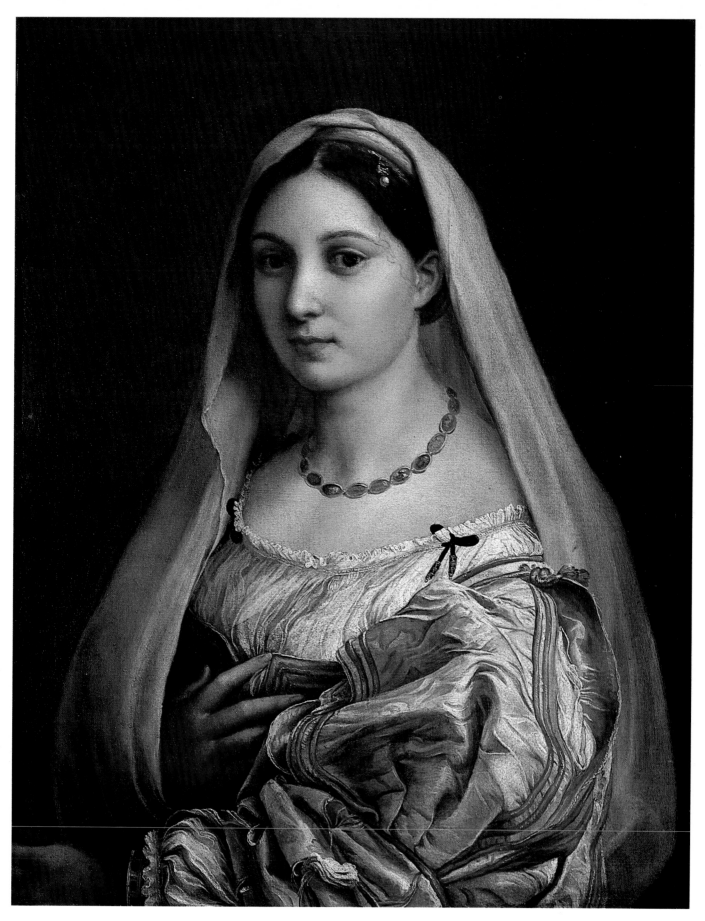

81. Portrait of a Woman (La Donna Velata)
82x60,5 cm
Florence, Galleria Palatina (Pitti Palace)

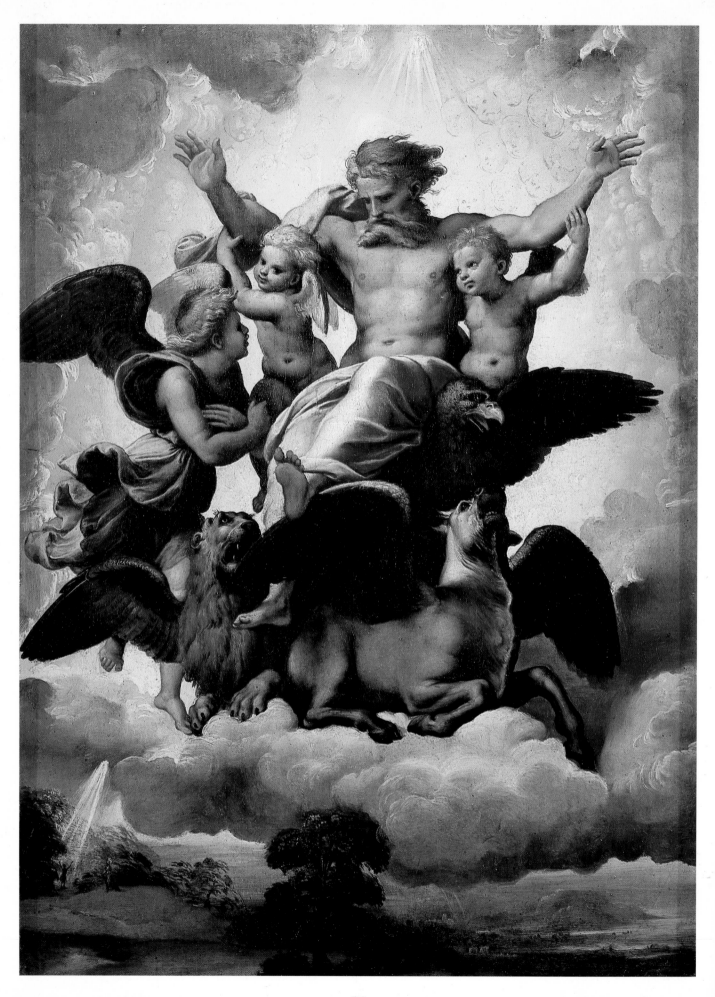

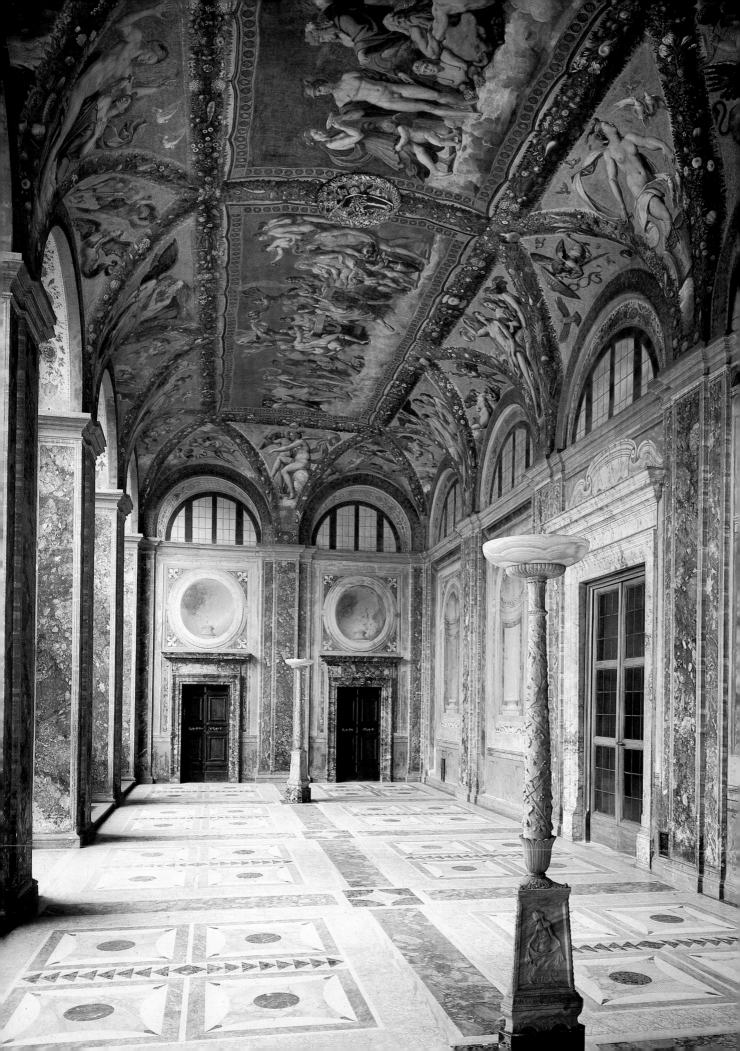

82. *The Vision of Ezekiel*
40x30 cm
Florence, Galleria Palatina (Pitti Palace)

83. *The Loggia of Psyche*
Rome, La Farnesina

84. *The 'Stufetta' of Cardinal Bibbiena in the Vatican Palaces*

85. *The Second Loggia, called 'Raphael's Loggia', in the Vatican Palaces*

86-88. *The 'Loggetta' in the Vatican Palaces, with its frescoes by the school of Raphael, and details of the grotesque decoration*

In the following year, 1517, Agostino Chigi commissioned Raphael to decorate the ground floor loggia of the villa in which the artist had painted the *Galatea* five years before. Like the *Galatea* and the *Stufetta*, this cycle reflects the cultured atmosphere which flourished in Rome under Julius II and Leo X. The frescoes represent the *Story of Psyche*, a myth derived from the *Golden Ass* of Apuleius (2nd century A. D.). Although the preparatory drawings and the general conception of the stories are by Raphael, the bulk of the painting was carried out by his pupils, notably

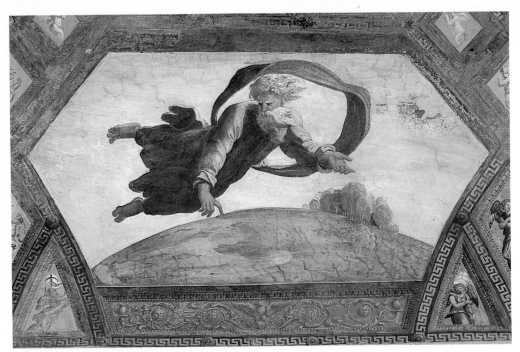

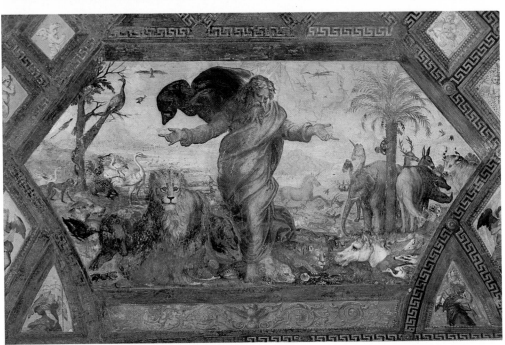

89-92. School of Raphael
Details of the fresco
decoration of the Second
Loggia showing: the
Separation of Land and
Water; the Creation of the
Animals; Isaac and Rebecca
Spied upon by Abimelech;
Jacob's Dream

93. Portrait of a Woman
(La Fornarina)
85x60 cm
Rome, Galleria Nazionale

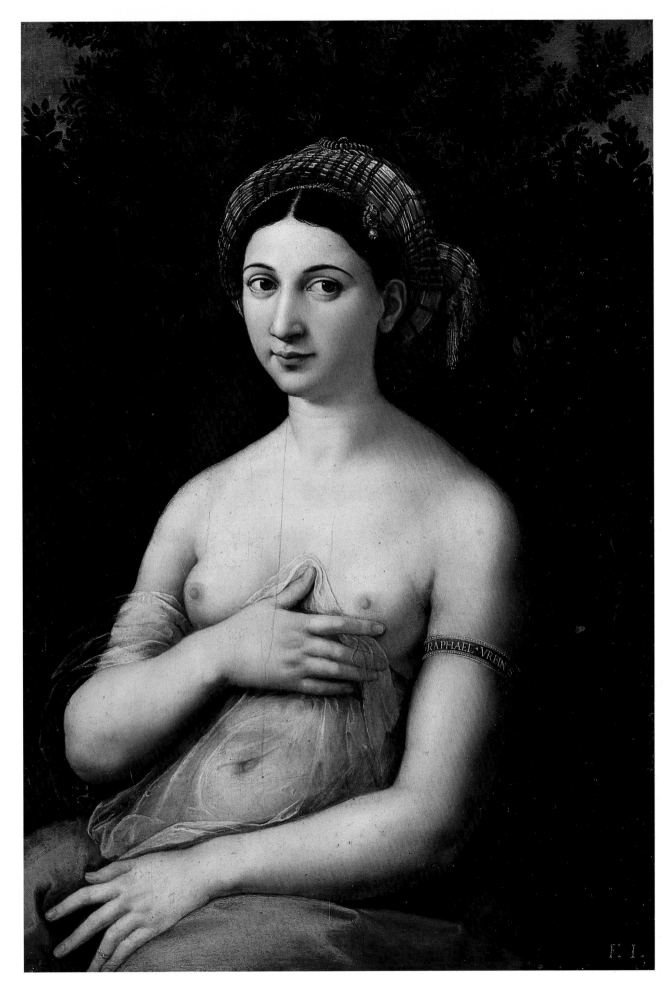

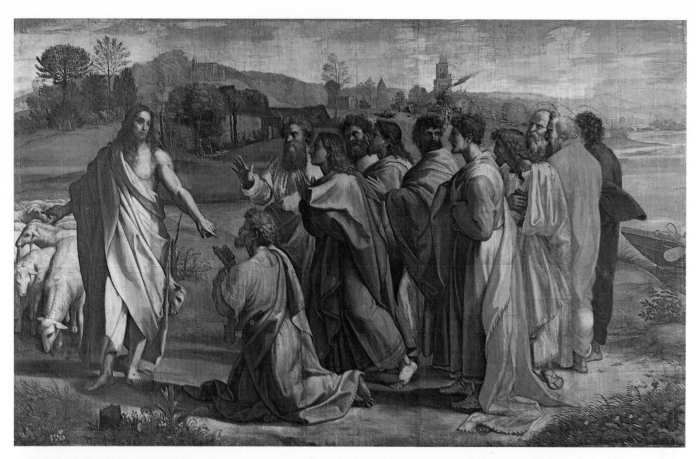

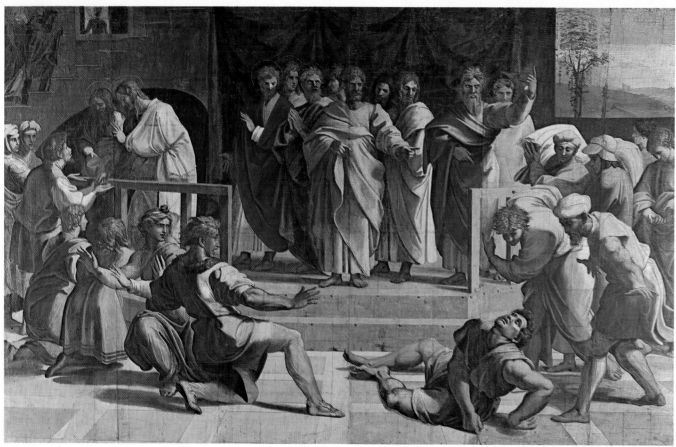

94, 95. *Cartoons for the tapestries of the Sistine Chapel*
London, Victoria and Albert Museum

96. *Portrait of Leo X with two Cardinals*
155.5x119.5 cm
Florence, Uffizi

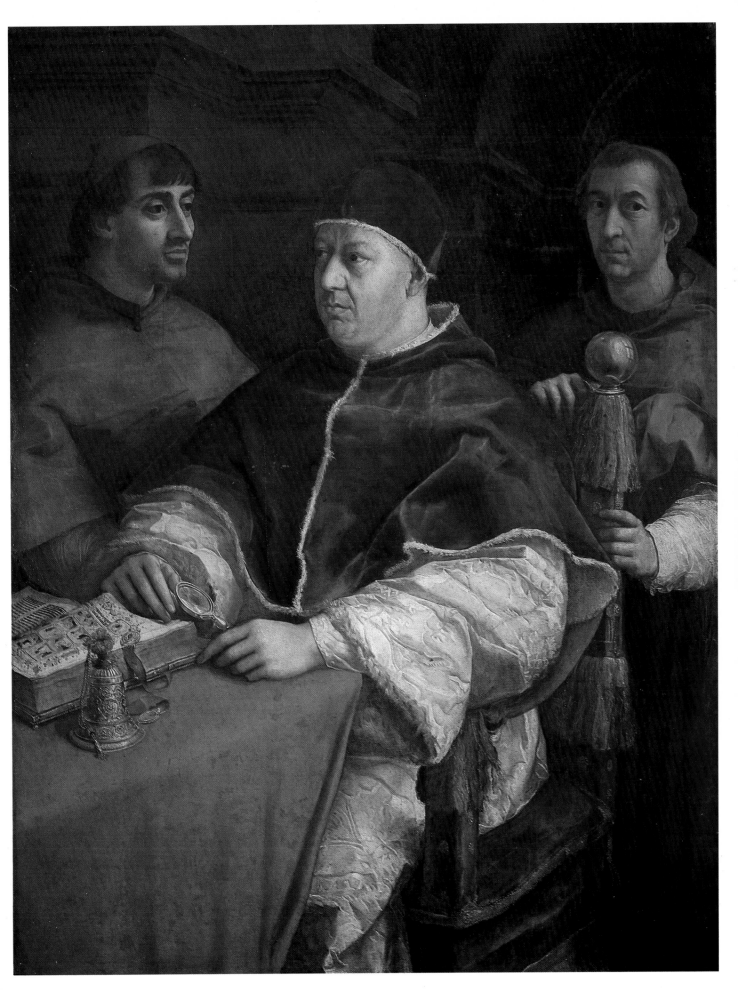

Giovanni da Udine (who painted the rich plant festoons of the frame) with the collaboration of Giulio Romano, Raffaellino del Colle and Gianfrancesco Penni. The two major scenes were painted in the vault. They are *The Marriage of Cupid and Psyche* and the *Council of the Gods*, conceived in terms of tapestries and embroideries.

Some elements deriving from Michelangelo are present in Raphael's works from the period after 1517. *The Vision of Ezekiel* is a typical example. The *Vision* shows the same balanced composition present throughout Raphael's works. The origin of the subject is the Bible (*Ezekiel*, 1:4-12). But instead of describing the four *Kerubim* (inspired by Babylonian iconography) as the Prophet did, Raphael represents a classical divinity with the traditional symbols of the Evangelists. This interpretation is confirmed by those critics who, like Antonio Natali, can see in the painting the apocalyptic vision of St John at Patmos. A centrally placed tree dominates the low, broad landscape and the sky is turbulent and stormy. The divine group hovers amid the clouds, surrounded by an aura of bright light. The angel, eagle, lion and ox which symbolize the Evangelists, together with two cherubs, spiral around the vigorous central figure. The painting, now in the Pitti Gallery in Florence, is believed to have been painted in 1518. Like many other paintings by Raphael, it was removed to Paris by Napoleon's army and returned to Tuscany in 1815.

Raphael was very active during the last two years of his life. Francis I, King of France, commissioned two paintings from him in 1518: the first representing *St Michael* and the second, the *Holy Family*. Critics have attributed both to Raphael's workshop, underlining the *chiaroscuro* effects and the leaden tones which mark them. Raphael himself was engaged with his project for the decoration of the Vatican Loggias, which was completed in 1519.

But his greatest masterpiece, possibly the only work he executed without help during these last years, is the *Portrait of Pope Leo X and Cardinals Luigi de' Rossi and Giulio de' Medici* (later to become Pope Clement VII), both relatives of the Pope. This group portrait (which created a sensation, notwithstanding the existence of precedents) is focused on the central figure of the Pope. The two Cardinals, Luigi de' Rossi on Leo's right (whose sharp features, modelled by strong *chiaroscuro* effects, suggest the hand of Giulio Romano) and Giulio de' Medici on his left, act as a royal escort. An illuminated prayer book lies open on the table in front of Pope Leo. On the same table rests a finely carved bell. Both objects undoubtedly reveal the exquisite tastes of the Pope who was, as we have seen, an active patron of the arts. The uniform tone of color, expressed in various red nuances; the quiet atmosphere, alluding to the power of the Pope and the splendor of his court; and the compositional harmony, make this portrait one of the most admired and significant works of Raphael. These paintings symbolically close the painter's career. He had enjoyed the patronage of two Popes and his presence in Rome had made the city the most important artistic center in Italy.

His map of ancient Rome was dedicated to this task and to recovering evidence of Rome's former greatness. He worked on it throughout 1519, and aroused great enthusiasm. A letter of praise by Castiglione, written in Latin after the death of the artist, summarizes this enthusiasm.

Much of Raphael's energy during these last years was directed toward public activity, or at least toward commissioners who were influential in city life and life within the Papal States (he designed a villa, known as the *Villa Madonna*, for Cardinal Giulio de' Medici). Furthermore, many critics attribute to him a series of compositions of the Holy Family and of Saints which were then executed by his followers. The famous portrait of a young woman, called *La Fornarina*, must also be viewed in this perspective, although it is signed, in Latin, "Raphael from Urbino". The signature is engraved on the thin ribbon that the girl wears just under her left shoulder. Tradition identifies her with Margherita Luti, a Sienese woman whom Raphael loved, the daughter of a baker from the Roman district of Santa Dorotea. The stiffness of her features and the heavy *chiaroscuro* effect make *La Fornarina* an almost certain workshop piece, for Raphael's own work from this period is far more delicate.

According to Vasari, Raphael's pupils — among them Giulio Romano, Gianfrancesco Penni, Vincenzo Tamagni, Perin del Vaga and Polidoro da Caravaggio — executed a cycle of thirteen *Bible Stories* in the vaults of the Logge adjoining the buildings that Bramante had built in the Vatican for Julius II. The Gallery was planned by Raphael, who also designed a decorative cycle of grotesques and stucco-reliefs. The latter were executed according to the ancient technique studied during the excavation of the *Domus Aurea*. The *Bible Stories* occupied Raphael's workshop from 1518 to 1519. They are reknown both for their pictorial value and for the influence they had on later decorative cycles.

The Biblical episodes were painted in the ceiling vaults, within differently shaped frames. Together they form a swarm of figures, isolated and in groups, arranged in an extraordinary variety of compositions and poses. Michelangelo's *Doni Tondo* introduced mannerism as a principle of figure design; the Vatican *Logge* introduced descriptive mannerism, a style of painting divorced from the precepts and principles of the early Renaissance. This style gave rise to lively and refined images packed with allusions, symbols and allegories, and often inspired by literary texts. It soon became an international movement. It was used with, or instead of, the classicizing tendency from which it originated, throughout the 16th century.

Raphael's pupils later reaffirmed their interest in classical antiquity and its interpretation in the decoration of the *Loggetta*, a small porch adjacent to the above-mentioned *Stufetta*, or bath room, of Cardinal Bibbiena. The decorative program consisted of grotesque figures and of scenes from the Apollo myth. Only two of the three original paintings have been preserved. The scholar, Regid de Campos, reconstructed the third scene, whose theme was almost

certainly the Flaying of Marsyas. The other two scenes represent Olympus praying to Apollo, and Apollo and Marsyas. Architectural structures, animals, winged cherubs and false niches containing reproductions of statues (which Regid de Campos has identified as the *Seasons*) — similar to those which appear in Roman wall paintings — accompany the three scenes. This refined decorative complex was the logical completion of the *Logge* and the last reflection of the classical tendencies of art at the court of Leo X. Raphael was overwhelmed by commissions by this time. He dedicated himself to the design and planning of the works which were entrusted to him, and left the material execution to his pupils. The latter participated (together with Sebastiano del Piombo, who painted in a Michelangelo-like style) in the decoration of the fourth room of the Vatican Palace, the Stanza di Costantino. Here Raphael's influence is weaker than in the other rooms. The figures are extremely agitated. They violate that norm which Raphael observed even in his more dynamic creations, for instance, the frescoes for the Stanza di Eliodoro.

Raphael's health deteriorated rapidly, undermined by his relentless activity and by the excesses of his private life. Bad health prevented him from finishing the *Transfiguration*, now in the Vatican Museum. Vasari, not without prejudice, compares the unrestrained life of Raphael to the austere and heroic one of Michelangelo, of whom he was a passionate admirer and around whose art he had structured his *Lives of the Artists*. Cardinal Giulio de' Medici commissioned the *Transfiguration* in 1517 to Raphael for the French Cathedral of Narbonne. However, it remained in San Pietro in Montorio after 1523. Taken to Paris 1797, it was brought back in its present location in 1815.

The composition of the *Transfiguration* is divided into two distinct parts: the Miracle of the Possessed Boy on a lower level, in the foreground; and the Transfiguration of Christ on Mount Tabor, in the background. The transfigured Christ floats in an aura of light and clouds above the hill, accompanied by Moses and Elijah. Below, on the ground, are his disciples. Some are dazzled by the light of glory, others are in prayer. The gestures of the crowd beholding at the miracle link the two parts together: the raised hands of the crowd converge toward the figure of Christ. In this very grand composition Raphael has summed up all the elements present in the best of contemporary painting, including references to classical antiquity, Leonardo da Vinci (without doubt based on his recall of impressions garnered during his stay in Florence), and — not without a certain narcissism — himself. This work sets the stage (just as surely as Michelangelo's *Doni Tondo*) for Mannerism. The numerous drawings (both by Raphael and pupils) for the characters in the painting, together with the number of variants of the first draft which were revealed by restoration work in 1977,

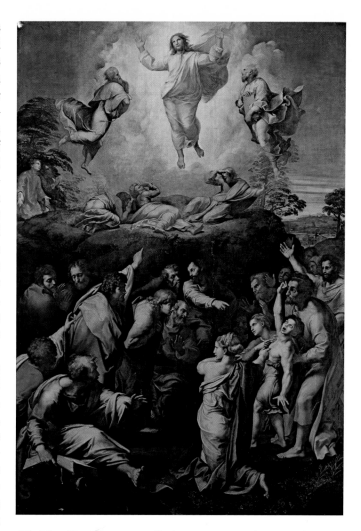

97. The Transfiguration (before restoration)
405x278 cm
Vatican, Pinacoteca

98-100. The Transfiguration, with details (after restoration)

show just exactly how carefully meditated a composition it is. The restoration also dispelled any doubts as to the authenticity of the attribution to Raphael; the retouching and corrections are proof that the painting (although unfinished) is actually entirely in his hand.

The *Transfiguration* is the last bequest of an artist whose brief life was rich in inspiration, where doubt or tension had no place. Raphael's life was spent in thoughts of great harmony and balance. This is one of the reasons why Raphael appears as the best interpreter of the art of his time and has been admired and studied in every century.

On 6 April 1520, precisely 37 years after he was born, Raphael died in Rome, the city that he had helped make the most important center of art and culture that had ever existed.

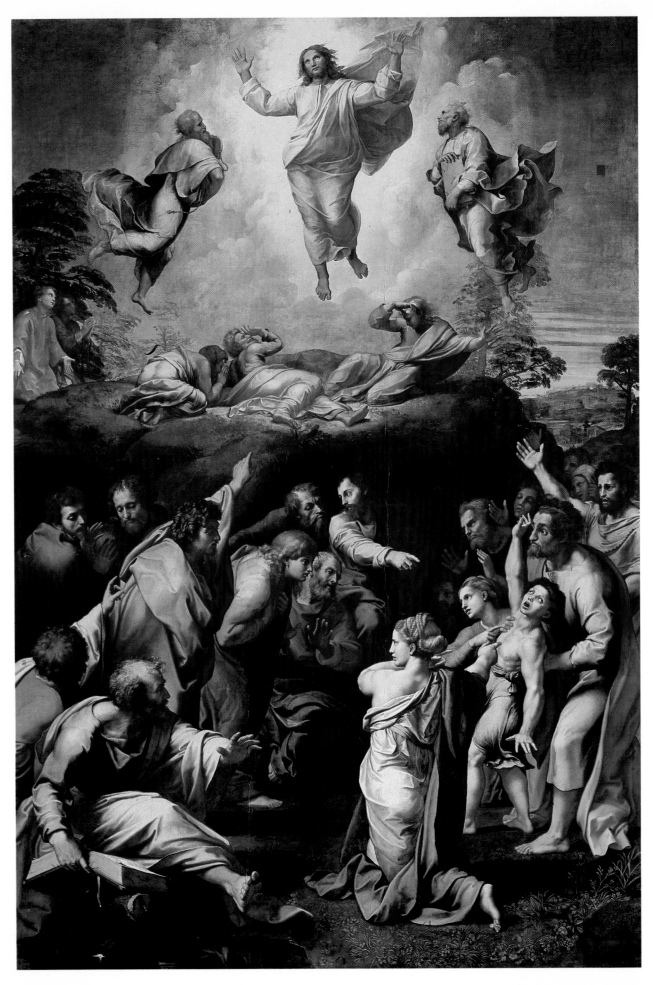

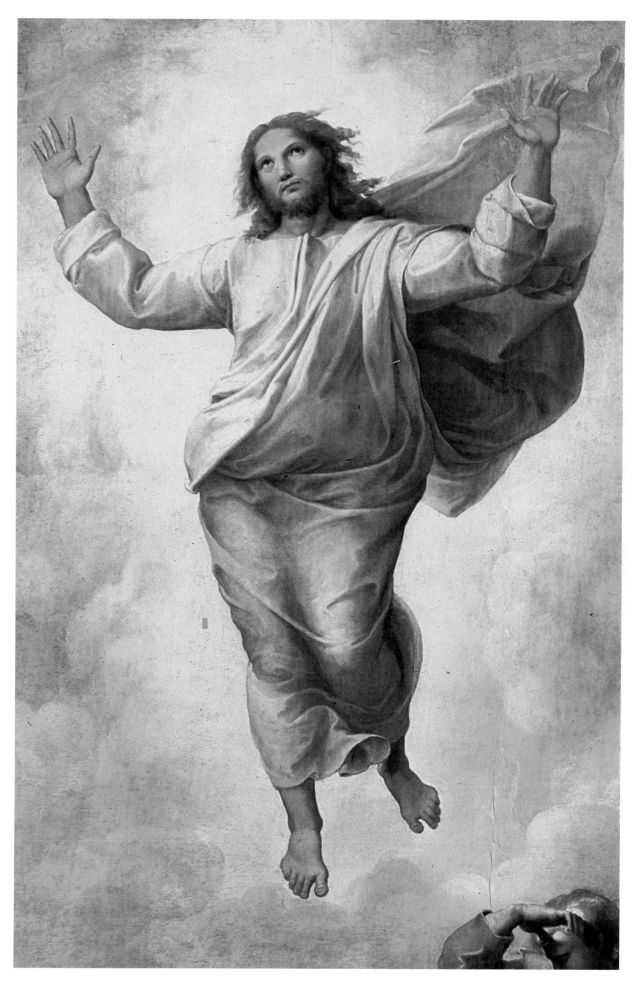

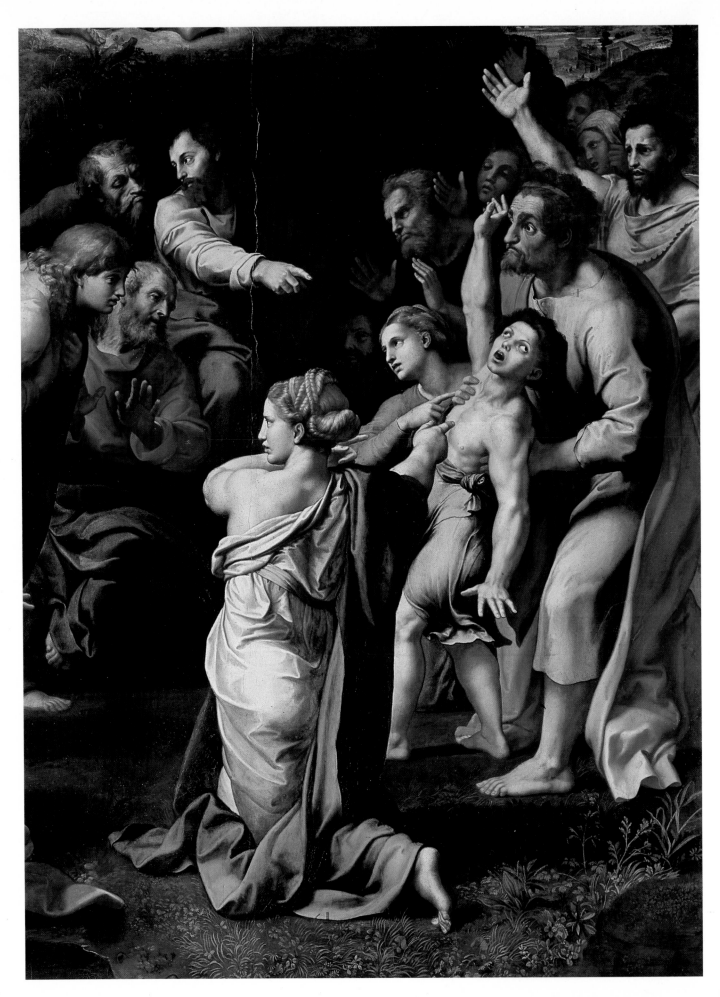